IMAGES
of Rail

TOLEDO RAILROADS

IMAGES
of Rail

TOLEDO RAILROADS

Kirk F. Hise and Edward J. Pulhuj

ARCADIA

Published by Arcadia Publishing
Charleston SC, Chicago IL, Portsmouth NH, San Francisco CA

Printed in Great Britain

Library of Congress Catalog Card Number: 2005922322

For all general information contact Arcadia Publishing at:
Telephone 843-853-2070
Fax 843-853-0044
E-mail sales@arcadiapublishing.com
For customer service and orders:
Toll-Free 1-888-313-2665

Visit us on the internet at http://www.arcadiapublishing.com

CONTENTS

INTRODUCTION

The following photos, maps, and documents have been collected over a period of 60 years or so. This book is just a glimpse into the past 150 years of railroad history.

The circular map of the Toledo area was drawn c. 1920 by an unknown person. All of the railroads named here entered Toledo, but there are some inaccuracies in locations. Toledo was, and is, a rail hub. The Toledo Terminal Railroad and New York Central Railroad maps will aid the reader in locating many of the stations, bridges, roundhouses, buildings, yards, and towers.

We hope that this book will bring you enjoyment and an appreciation of how important railroads were and are to Toledo. Lastly, to the people who worked for the railroad in the past and present—may this book remind you of time you spent in an indirect way helping to create this book!

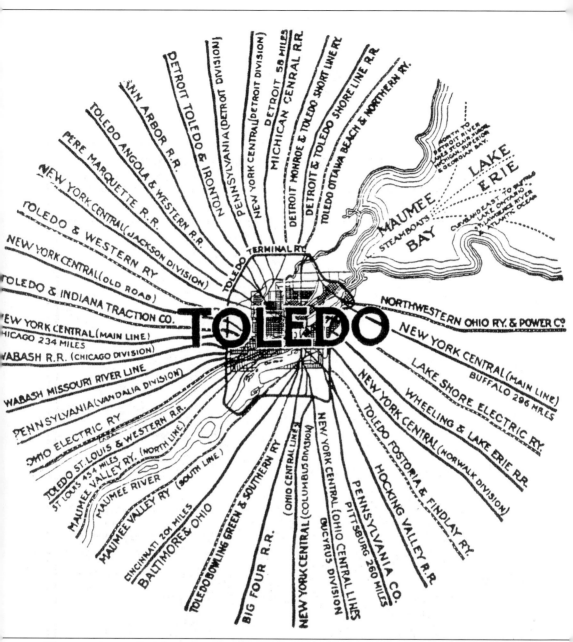

This map shows all of the railroad and trolley lines that have serviced Toledo over the last 150 years. Please note that some of the above railroads are not in their correct locations. This includes lines that have been merged and merged again and again until there are now only four railroads that service Toledo. These railroads are Interstate Railway (Ann Arbor), Canadian National (CN), Chessie Seaboard Express (CSX), and Norfolk & Southern. (K. Hise collection.)

One

MAPS

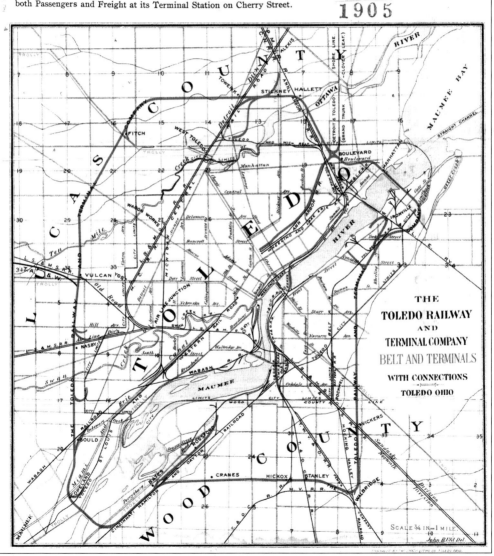

THE TOLEDO RAILWAY AND TERMINAL COMPANY

Transfers Cars between the different railway lines, industries and warehouses in and about Toledo. Its tracks extend entirely around the city CONNECTING WITH ALL TOLEDO RAILROADS. It also affords first class terminal facilities for both Passengers and Freight at its Terminal Station on Cherry Street.

1905

THE
TOLEDO RAILWAY
AND
TERMINAL COMPANY
BELT AND TERMINALS
WITH CONNECTIONS
TOLEDO OHIO

This was a map that could be found on the back of letterhead that was issued by the Toledo Railway & Terminal Company in 1905. (Hise collection.)

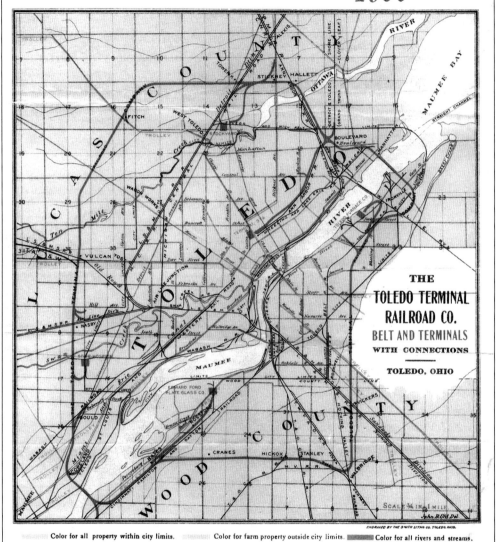

THE TOLEDO TERMINAL RAILROAD CO.

Its line extends entirely around the city, having direct track connections with all Toledo Railroads.

Excellent factory sites adjoining the Toledo Terminal R. R., accessible to city and interurban car service, can be secured at a reasonable cost per acre.

1909

THE
TOLEDO TERMINAL
RAILROAD CO.
BELT AND TERMINALS
WITH CONNECTIONS

TOLEDO, OHIO

SCALE ¾ IN. 1 MILE

John B.Uhl Del.

ENGRAVED BY THE SMITH LITHO. CO. TOLEDO. OHIO.

Color for all property within city limits. Color for farm property outside city limits. Color for all rivers and streams.

Parties contemplating the establishment of industries, warehouses, docks, elevators, etc., in the vicinity of Toledo are invited to communicate with the General Manager at Toledo, who will promptly furnish them with full information in regard to desirable locations, switching rates, car supply, etc.

THOMAS B. FOGG,
General Manager.

The Toledo Railway & Terminal was reorganized into Toledo Terminal Company, and this map has an updated letterhead. Look closely for the changes that have occurred over the past four years since the last map was issued. This map also shows different industries that it serviced at this time. (Hise collection.)

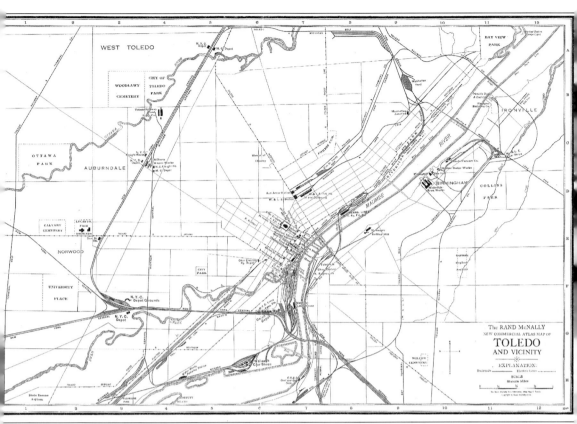

This map from 1917 shows central and downtown Toledo and all of the railroads that served the city. Also, from this map, you can see all of the trolley lines that helped support the growing city. (Pulhuj collection.)

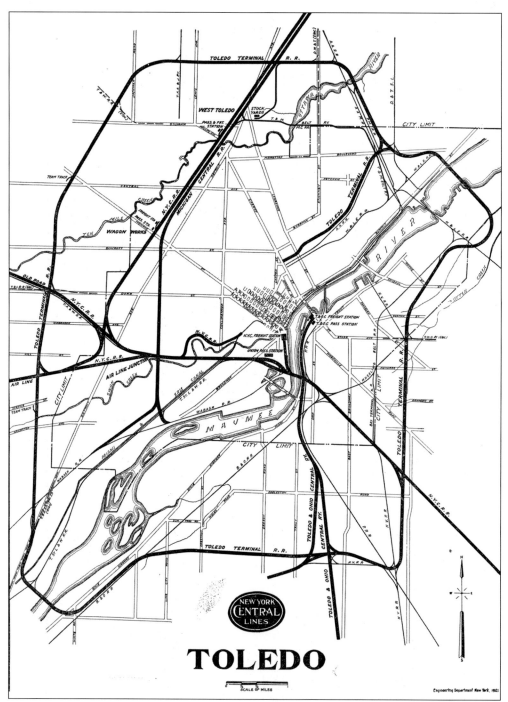

TOLEDO

This New York Central map from 1921 shows Toledo and all of the lines that they serviced. Notice that the Toledo Terminal is highlighted. This line was partially owned by New York Central. The Pere Marquette & Cinncinatti and Hamilton & Dayton rail lines also had shared ownership of the Toledo Terminal line. (Pulhuj collection.)

Two
DOCUMENTS

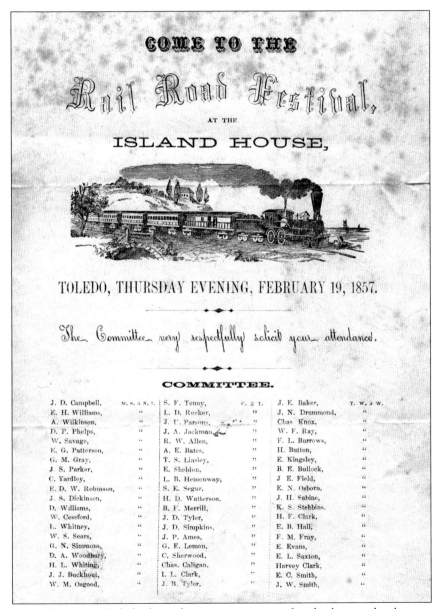

Throughout the years, Toledo hosted train expositions for displaying the latest railroad equipment. This *c.* 1857 flyer displays an exposition at the Island House, which used to stand on the Middlegrounds. (Pulhuj collection.)

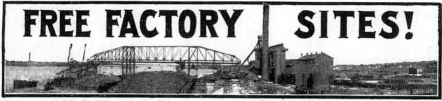

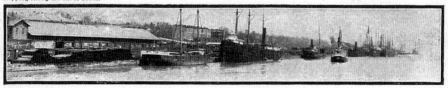
This advertisement for the Toledo Railway & Terminal was found in *McClure's Magazine c.* 1904. The advertising lists excellent reasons for starting or creating a business in Toledo. (Pulhuj collection.)

——THE——
Cincinnati, Jackson & Mackinaw
RAILWAY CO.
THE DIRECT LINE BETWEEN
TOLEDO
——AND——

Tecumseh, Marshall, Battle Creek, Allegan, Holland, Grand Rapids, Muskegon
AND ALL WESTERN MICHIGAN POINTS,

Hudson, Bryan, O., Paulding, O., Van Wert, Celina, Greenville, Germantown, Cincinnati, Louisville,
——AND——

ALL POINTS SOUTH, EAST AND WEST.

The Attention of the Public is respectfully called to the advantages offered by this line, with the request that it be favored with a share of its Patronage.

This is the only line reaching **DEVIL'S LAKE**, the well-known SUMMER RESORT, but two hours' ride from Toledo. Excellent Fishing, Splendid Boating, and Bathing, and ample Hotel Accommodations at very reasonab'e rates for all who may wish to spend a portion of the summer at this popular resort. Gull Lake, Goguac Lake and Sand Lake, located on this line, are also noted for excellent Fishing, Boating and Bathing.

SPECIAL LOW RATES are made to these Resorts during the Summer Season. Tourists' Tickets to all the well-known Resorts in Northern Michigan at greatly reduced rates are on sale at all the principal ticket offices.

TICKETS VIA THE C., J. & M. RY. ARE ON SALE AT ALL PRINCIPAL TICKET OFFICES.

Trains arrive at and depart from Wheeling & Lake Erie Passenger Station, Cherry Street, Toledo, Ohio.

Deliver Freight for points on or reached by this line at Wheeling & Lake Erie Freight Depot, Cherry Street. Mark and consign via C., J. & M. Ry.

For further information Inquire at Company's Office, Room No. 10 St. Clair Building, at Depot Ticket Office, or at Gates' Union Ticket Office, Boody House, Toledo, Ohio.

F. B. DRAKE, T. C. M. SCHINDLER,
General Manager. General Freight and Passenger Agent.

R. ST. JOHN,
Contracting Agent,

The Cincinnati, Jackson & Mackinaw Railway bought the Michigan & Ohio Railway March 25, 1887. The M&O had entered Toledo in December 1883 from Dundee over the Ann Arbor Railroad. It ran west to Allegan, Michigan. A portion of the CJ&M in turn later became the Detroit, Toledo & Milwaukee. (Pulhuj collection.)

The Detroit, Toledo & Milwaukee formed July 22, 1897 to operate the Cincinnati, Jackson & Mackinaw Railway line west from Dundee to Allegan, Michigan. This company came under Lake Shore & Michigan Southern and Michigan Central control December 31, 1905. This advertising was published c. 1899. Passenger trains were later routed at Tecumseh south to Lenawee Junction and over the New York Central Old Road to Toledo. The Tecumseh to Dundee portion of the line was leased to the Detroit, Toledo & Ironton. (Pulhuj collection.)

Lake Shore & Mich. Sou. Railroad.

With its Connections, the
MOST RELIABLE ROUTE
To all points in the Eastern and Western States and the Dominion of Canada.

Four Express Trains Leave Chicago Daily.

NO CHANGE OF CARS BET. CHICAGO & BUFFALO.
CONNECTIONS ARE

At **Detroit** with Grand Trunk and Great Western Railways.

At **Toledo** with T. & W. and Dayton & Michigan Railroads.

At **Fremont** with the Fostoria, Lima & Urbana Railroad.

At **Clyde** with C. D. & E. R. R., tor Urbana, Springfield, Dayton and Cincinnati.

At **Monreville** with Sandusky, Mansfield & Newark R. R. for Shelby, Mansfield, Mt. Vernon, Newark, Zanesville and Columbus.

At **Elyria** with Cleveland, Columbus and Cincinnati Railroad.

At **Cleveland** with Atlantic & G. W., and Cleveland & Pittsburg.

At **Girard** with Erie & Pittsburg R. R.

At **Erie** with Philadelphia & Erie Railroad for Philadelphia, Baltimore and Washington.

At **Dunkirk** with Erie Railway.

At **Buffalo** with Erie and New York Central Railways, for all points in New York and the New England States.

Passengers coming West, by the South Shore Line, have choice of four express trains from Toledo over this first-class Raod; or coming to Detroit, via Canada, there connect with the Michigan Southern, through from

☞ DETROIT TO CHICAGO WITHOUT CHANGE OF CARS.

Elegant and most comfortable Sleeping Cars are run on all Night Trains, through to Detroit, Cleveland & Buffalo without change. Palace Cars on Day Trains.

We hold out the following inducements for public patronage :

Good Clean Eating Houses, Luxurious Sleeping Cars, Day Coaches with all Modern Improvements, a Smooth Track, not second to any on this Continent.

This Lake Shore & Michigan Southern advertising is an early one and could be from the 1870s. The LS&MS was one of the early predecessors of the New York Central System. (Pulhuj collection.)

Speed, Safety, Comfort.

Sleeping, Dining and Parlor Cars.

—TO—

Buffalo, Albany, New York, Boston, and the East.

The Unrivaled Passenger Route. The Shortest, Quickest, and most direct Route from

TOLEDO

TO ST. THOMAS,

BUFFALO, NIAGARA FALLS, NEW YORK, BOSTON,

And all Principal Points in the East, Detroit, Saginaw and Bay City. This is a Direct Route from Toledo to Mackinaw City and Island, also Marquette and Northern Peninsula.

PALACE DINING CARS

On Day Trains. Magnificent Drawing Room and Sleeping Coaches on all Trains.

☞ EXPRESS TRAINS DAILY ☜

Pass over this line, fully equipped with all modern appliances for Speed, Comfort and Safety Connections in Toledo and Detroit are made in Union Depot. No Transfer. GIVE THE ROUTE A TRIAL. Tickets and Sleeping Car Berths can be obtained at the Depot and Boody House Ticket Office.

O. W. RUGGLES,	**WM. GATES,**
Gen'l Passenger and Ticket Agent,	City Passenger and Ticket Agent,
CHICAGO.	57 Madison St., TOLEDO.

The Michigan Central took over control of the Canada Southern on December 12, 1882. This line crossed Canada and was a fast route between Detroit and the eastern U.S. (Pulhuj collection.)

18

The Toledo, Ann Arbor & Northern Michigan Railway opened in 1871 as the Toledo & Ann Arbor Railroad. Through construction and various reorganizations, it became the Toledo, Ann Arbor & Norh Michigan Railway about 1884. In 1885, the Ann Arbor Railroad was incorporated to take over the property. So this ad would date within that 10-year period. (Pulhuj collection.)

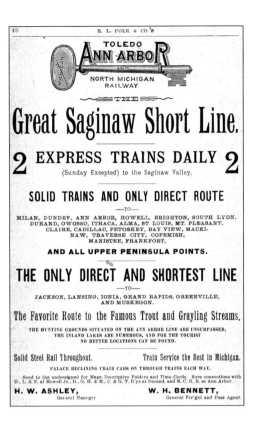

The Toledo & Ohio Central originally was named Ohio Central, and its line ran from Corning to Toledo. It was in operation by November 1, 1880. The name was changed to Toledo & Ohio Central Railway in 1892. This advertising was published around 1890. (Pulhuj collection.)

Toledo, Wabash and Western

RAILWAY.

Run their Trains in connection with Railroads at Toledo, Ft. Wayne, Peru, Logansport, Lafayette, Tolono, Decatur, Springfield & Jacksonville, for Quincy & Keokuk.

Passengers Carried Through to the Mississippi River Without Change of Cars.

ELEGANT SLEEPING CARS RUN ON ALL NIGHT TRAINS.

OFFICERS:

AZARIAH BOODY, President, N. Y. City | J. N. DRUMMOND, Sec. & Treas. Toledo
WARREN COLBURN, Asst. Pres., Toledo | JOHN B. CARSON, Gen. Ft. Agt., Toledo

GEO. H. BURROWS, Gen. Supt., Toledo, O.

JOHN U. PARSONS, Gen'l Ticket Ag't, Toledo, O.

☞ For list of Directors see page 109.

The Toledo, Wabash & Western Railroad was in service from Toledo to Quincy, Illinois, by the end of 1857. The name of this railroad changed first in 1858 to Toledo & Wabash Railway and then in 1865, back to the TW&W. On November 10, 1879, the Wabash, St. Louis & Pacific Railroad was formed. It carried that title until May 27, 1889, when under fire unification of all lines it became the Wabash Railroad. This advertising was published between 1865 and 1879. (Pulhuj collection.)

Three
BRIDGES

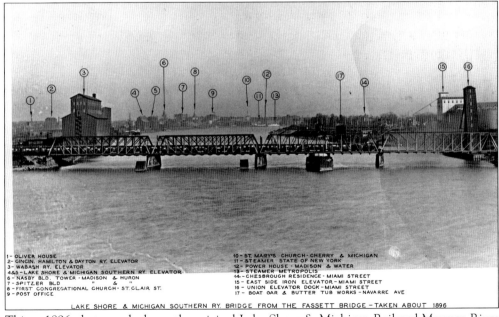

1- OLIVER HOUSE
2- CINCIN. HAMILTON & DAYTON RY. ELEVATOR
3- WABASH RY. ELEVATOR
4&5- LAKE SHORE & MICHIGAN SOUTHERN RY. ELEVATOR
6- NASBY BLD. TOWER - MADISON & HURON
7- SPITZER BLD " & "
8- FIRST CONGREGATIONAL CHURCH- ST. CLAIR ST.
9- POST OFFICE

10- ST. MARY'S CHURCH- CHERRY & MICHIGAN
11- STEAMER STATE OF NEW YORK
12- POWER HOUSE - MADISON & WATER
13- STEAMER METROPOLIS
14- CHESBROUGH RESIDENCE - MIAMI STREET
15- EAST SIDE IRON ELEVATOR - MIAMI STREET
16- UNION ELEVATOR DOCK - MIAMI STREET
17- BOAT OAR & BUTTER TUB WORKS - NAVARRE AVE

LAKE SHORE & MICHIGAN SOUTHERN RY. BRIDGE FROM THE FASSETT BRIDGE - TAKEN ABOUT 1896

This c. 1896 photograph shows the original Lake Shore & Michigan Railroad Maumee River Bridge that was built by the Lake Shore & Michigan Central Railroad. (Toledo Public Library.)

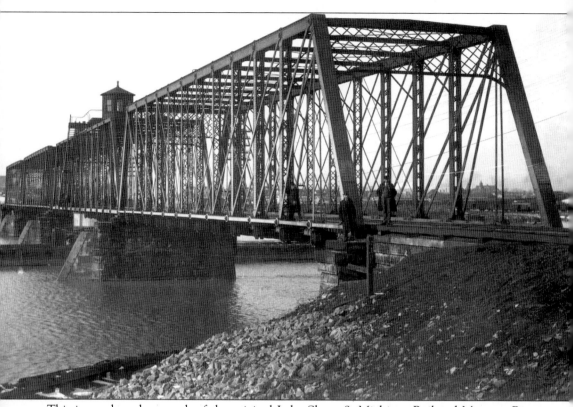

This is another photograph of the original Lake Shore & Michigan Railroad Maumee River Bridge, c. 1898. (K. Hise collection.)

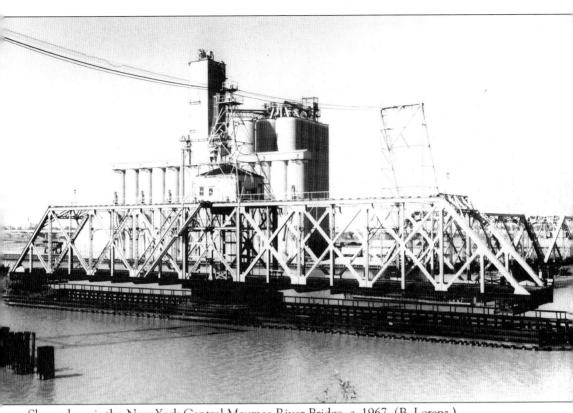

Shown here is the New York Central Maumee River Bridge, *c.* 1967. (B. Lorenz.)

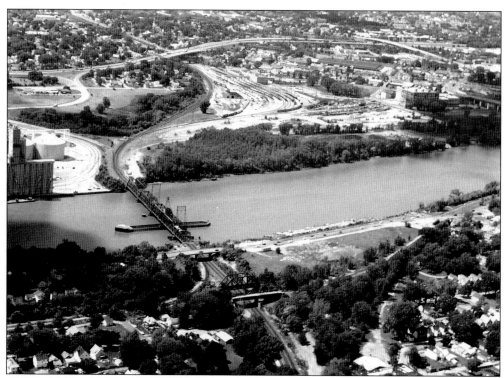

This *c.* 2001 aerial view shows the New York Central Maumee River Bridge and Toledo's Central Union Terminal. (Pulhuj.)

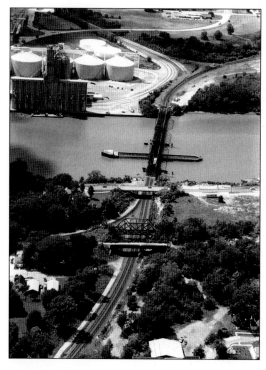

This *c.* 2001 photograph shows the old Pennsylvania Railroad and Toledo & Ohio Central Railroad Bridges. (Pulhuj.)

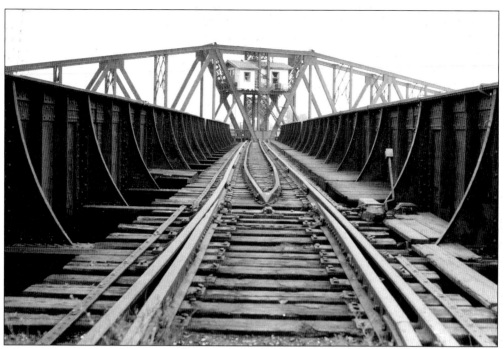

This is the Pennsylvania Railroad Maumee River Bridge, c. 1948. (B. Lorenz.)

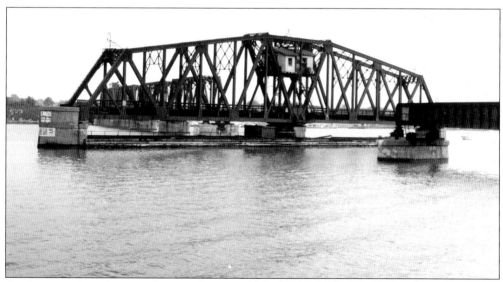

At the time this photograph was taken, c. 1985, the Pennsylvania Railroad Maumee River Bridge was out of service and was later removed. (B. Lorenz.)

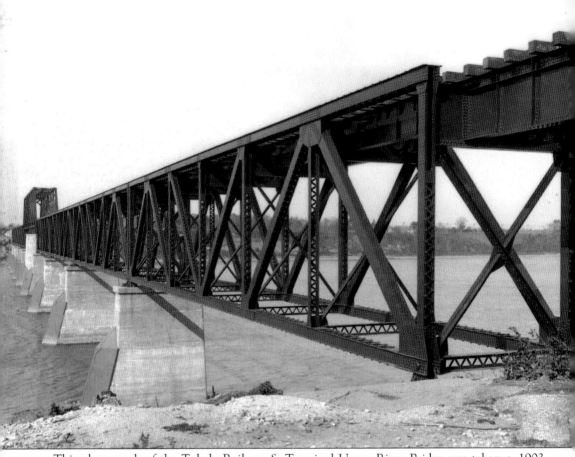

This photograph of the Toledo Railway & Terminal Upper River Bridge was taken *c.* 1903. (Toledo Public Library.)

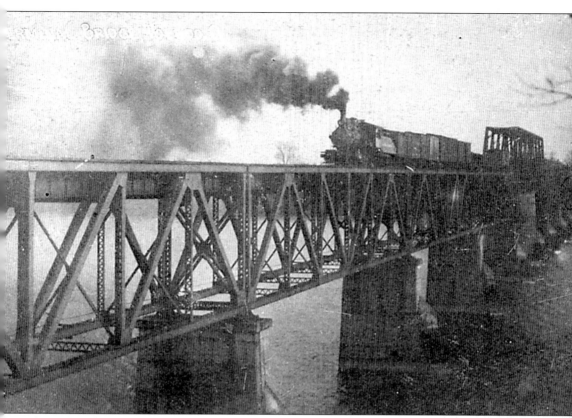

The Toledo Terminal Railroad Maumee Upper River Bridge was called the "Upper River Bridge" because it was built up-river from downtown Toledo. It was also built on a turning pedestal, but never had any machinery for turning operation. (Pulhuj collection.)

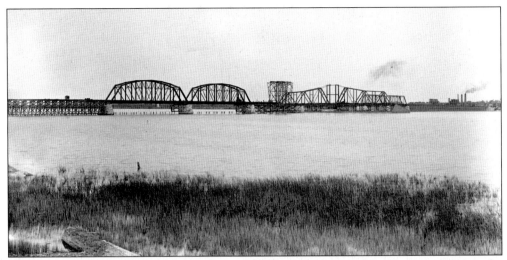

Here, c. 1903, the Toledo Railway & Terminal Railroad Maumee Lower River Bridge is under construction. This bridge was built as a single-track span and later rebuilt as a double-track bridge and is still in service today. It has also been struck by passing lake freighters. (Toledo Public Library.)

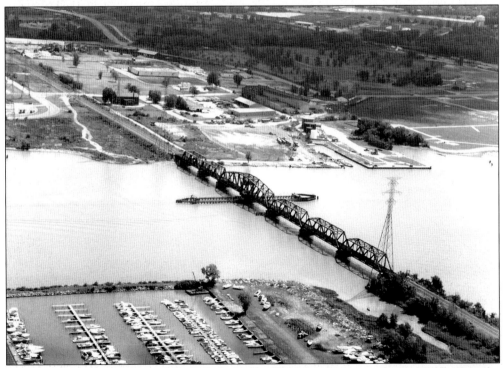

This is a c. 2001 aerial view of the Toledo Terminal Railroad Maumee Lower Bridge. Until a few years ago, this bridge could turn a full 360 degrees. Some years ago, two ships were outbound and an acquaintance was operating the bridge. The first ship called for the bridge to open—it passed, and the bridge started to swing closed when the second ship appeared. The bridge operator could not open against the ship, so he swung 180 degrees to let it pass, then went around to close it. The bridge has since been rewired and can only swing 180 degrees. (Pulhuj.)

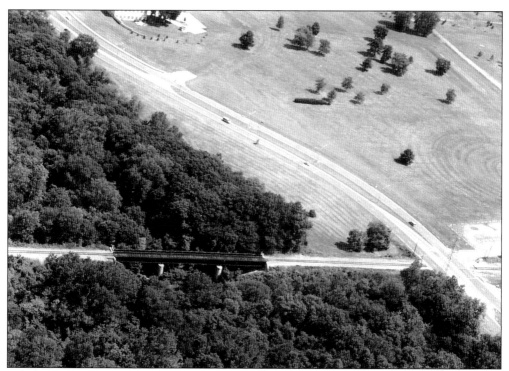

This aerial photograph of the Toledo Terminal Railroad Ten Mile Creek Bridge along Arlington Avenue was taken c. 2001. (Pulhuj.)

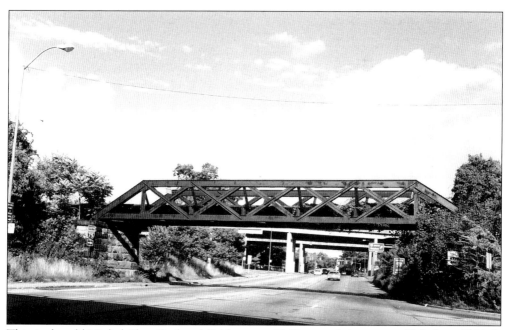

This is the old Nickel Plate Railroad Bridge over Collingwood Avenue in Toledo c. 2001. It was originally built by Clover Leaf Railroad and ran parallel with the present Anthony Wayne Trail. (Pulhuj.)

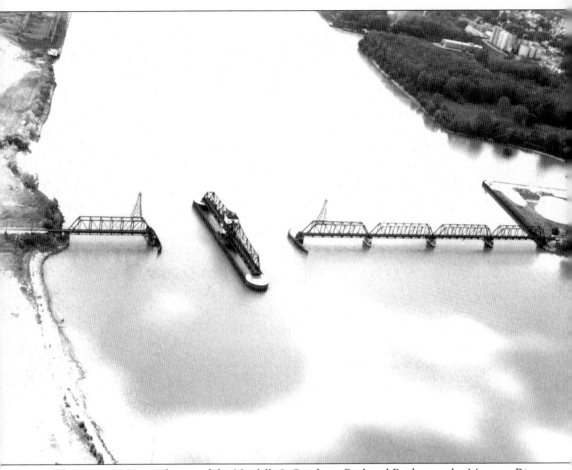

This is a c. 2001 aerial view of the Norfolk & Southern Railroad Bridge on the Maumee River. the bridge was recently sold to the Wheeling & Lake Erie Railroad. Norfolk and Southern will now use the Wheeling Belt line to reach the old New York Central main line in east Toledo and across the Maumee. (Pulhuj.)

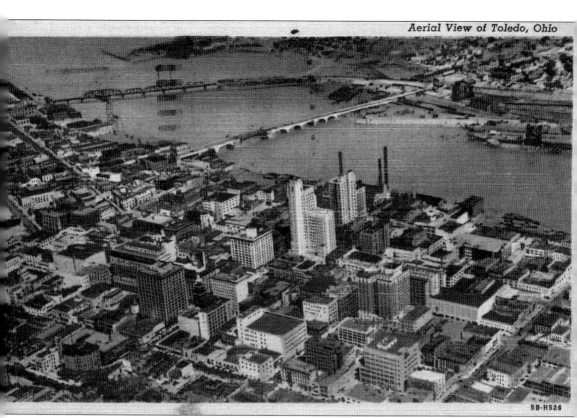

5B-H526

This aerial view of Toledo's downtown shows the Pennsylvania Bridge in the upper left-hand corner and the Toledo & Ohio Central Railroad yard in the top center. The Cherry Street Bridge was a highway bridge also used by streetcars and interurban lines. (Pulhuj collection.)

Roundhouse and Turntable Listings

Location	Railroad
Airline Junction 95'	New York Central
Airline Junction 95'	New York Central
Boulevard	Toledo Terminal
Fassett Street	Pittsburg, Fort Wayne & Chicago
New York Street	Pere Marquette
Lange	Detroit & Toledo Shore Line
Homestead	Wheeling & Lake Erie
Rossford	Baltimore & Ohio
Temperance	Detroit, Toledo & Ironton
Walbridge	Chesapeake & Ohio

(Note that this list contains all known roundhouses and turntables at the time of this publishing.)

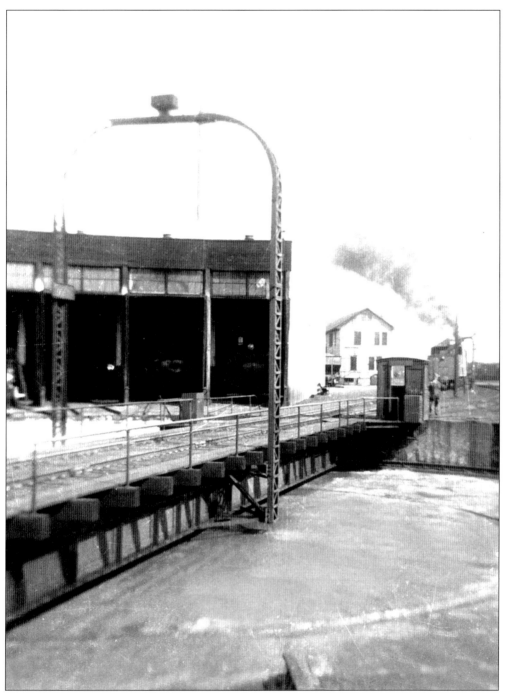

This is the Lang roundhouse and turntable, Detroit & Toledo Shoreline, c. 1949. Notice the yard office house in the background. The roundhouse was torn down in the 90s, but the turntable is still in use for turnaround engines for their trips northward. Also, this roundhouse was kept so clean that banquette meetings were held in it. (R. Hubbard.)

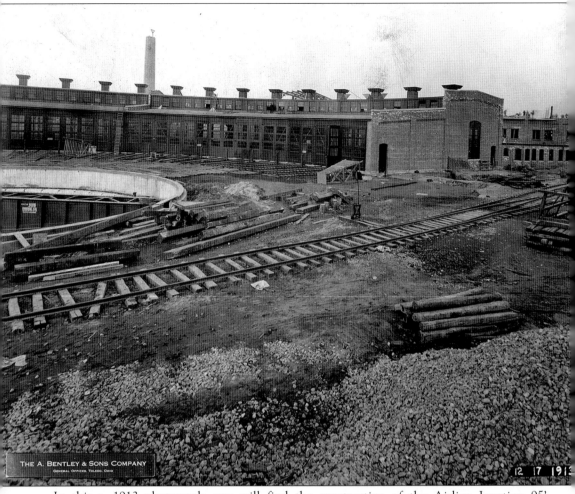

THE A. BENTLEY & SONS COMPANY
GENERAL OFFICES, TOLEDO, OHIO

12 17 1913

In this *c.* 1913 photograph, you will find the construction of the Airline Junction 95' roundhouse and turntable being installed. New York Central built a double roundhouse along Fehering Boulevard. They were both demolished, and a Sears building was constructed there. (Toledo Public Library.)

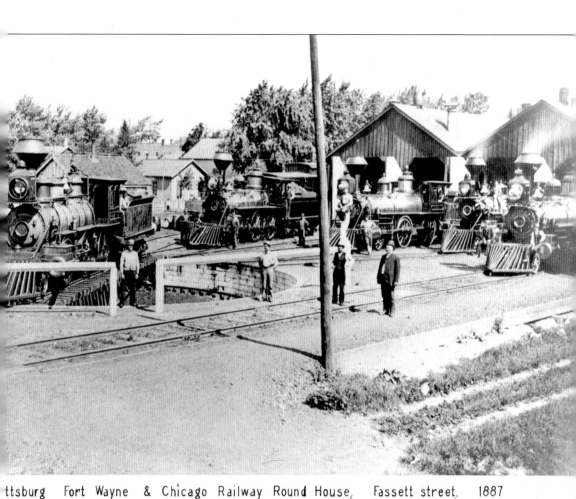

ttsburg Fort Wayne & Chicago Railway Round House, Fassett street, 1887

This photograph is of the Pittsburgh, Fort Wayne & Chicago roundhouse and turntable at Fassett Street, c. 1887. (Toledo Public Library.)

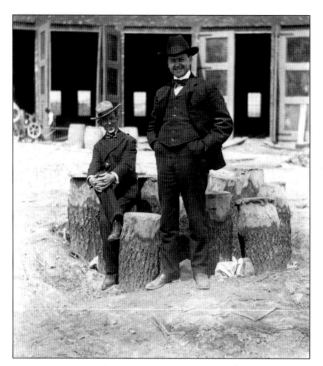

This c. 1903 photograph shows the Toledo Railway & Terminal Boulevard roundhouse with Mr. Hall and Mr. Waples, who were in charge of building the Toledo Railway & Terminal. (Toledo Public Library.)

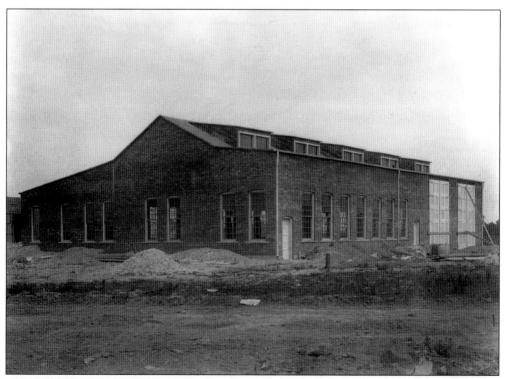

The Toledo Railway & Terminal Engine House was located at Boulevard Yard, c. 1903. This engine house stood until the 1980s. It was built at the turn of the century. (Toledo Public Library.)

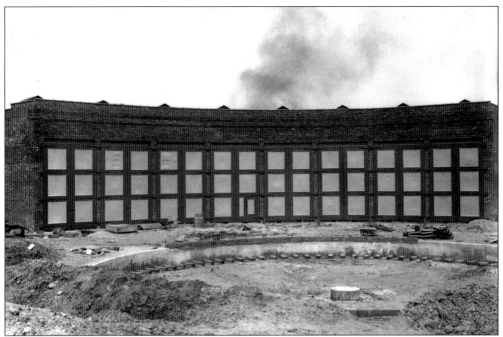

The Toledo Railway & Terminal Boulevard roundhouse was located at the corner of the Manhattan Boulevard and Hoffman Road, c. 1903. This roundhouse was standing until just a few years ago. Today, it is still possible to find some of the concrete floor. (Toledo Public Library.)

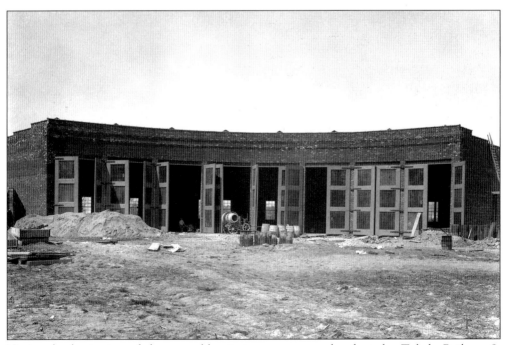

Notice the beginning of the turntable pit is not yet completed at the Toledo Railway & Terminal Boulevard Roundhouse in this c. 1903 photograph. (Toledo Public Library.)

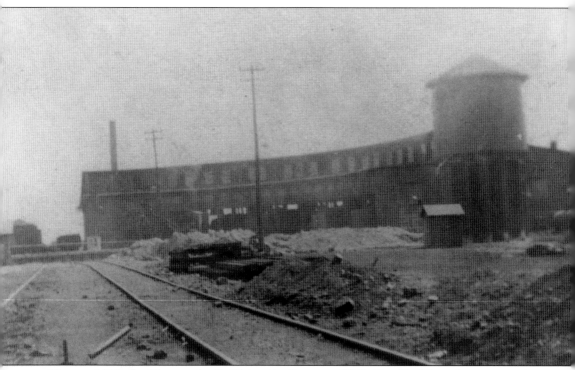

Here, c. 1910, the Chesapeake & Ohio roundhouse at Walbridge Yard is under construction. (K. Hise collection.)

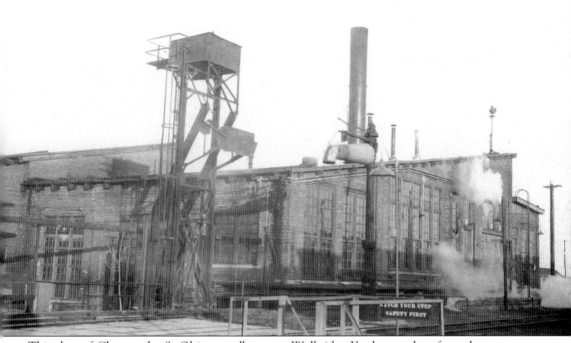

This shot of Chesapeake & Ohio roundhouse at Walbridge Yard was taken from the rear, c. 1980. (K. Hise.)

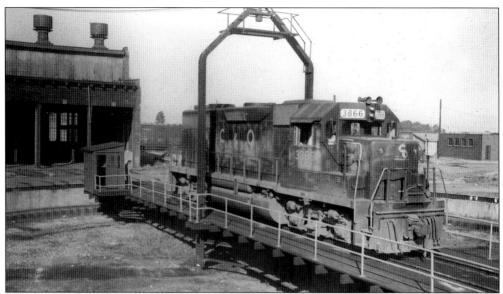

Here is the C&O Engine No. 3866 on turntable at Walbridge Yard in 1974. (K. Hise.)

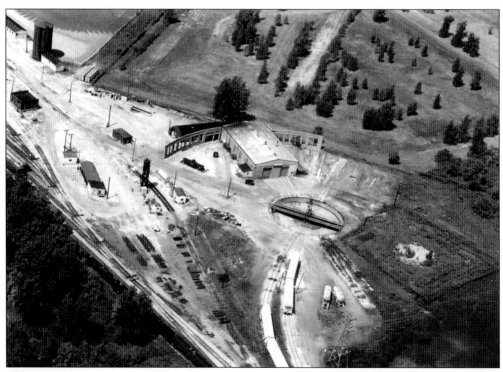

This aerial view of the Norfolk & Western's Homestead turntable and roundhouse was taken in 2001. (Pulhuj.)

Five

STATIONS

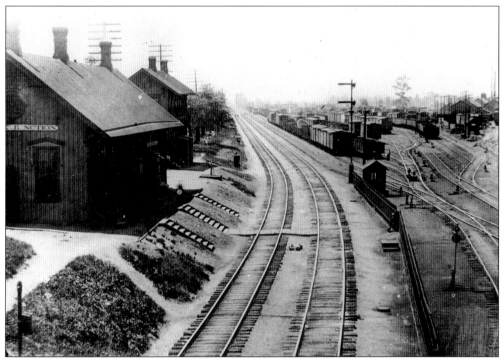

Airline Junction was the main freight yard of the Lake Shore & Michigan Southern; later it would become the New York Central in Toledo. It was named for the main line across northern Ohio to Chicago, which opened between Toledo and Elkhart, Indiana, in May 1857. The Erie & Kalamazoo line from Toledo, Adrian & Elkhart became the Old Road, after the Air Line was opened. The lines from Detroit to Toledo joined the Air Line here also. Swan Creek tower was on the east end of the yards. Nasby tower is on the west end of the yards, at the crossing of the former Toledo Terminal Railroad. Z tower was on the north side of Airline at the Detroit Division connection. This photograph was taken c. 1910. (Pulhuj collection.)

Station Listings

Location	Railroad
Airline Junction	New York Central
Auburndale	New York Central
Central Union Terminal	New York Central
Cherry Street	Ann Arbor
Cherry Street	Toledo & Ohio Central
Cherry Street	Toledo Terminal
Cherry Street	Wheeling & Lake Erie
Dorr Street	New York Central
Fassett Street	Toledo & Ohio Central
Front Street	Toledo & Ohio Central
Front Street	Wheeling & Lake Erie
Lafayette Street	Cincinnati & Lake Erie
Main Street	Toledo & Ohio Central
Manhattan Jct.	Ann Arbor & Wheeling & Lake Erie
Maumee	Nickel Plate
MC Junction	Nickel Plate / Michigan Central
Perrysburg	Baltimore & Ohio
Summit Street	Pennsylvania
Summit Street	Wheeling & Lake Erie
Sylvania	New York Central
Union Station	New York Central
Vienna	Michigan Central / New York Central
Wagon Works	New York Central
Walbridge	Pennsylvania
Water Street	Erie & Kalamazoo
West Toledo	Michigan Central / Canada Southern
West Toledo	New York Central

(Note: this list contains all known stations located in the Toledo area at the time of publishing.)

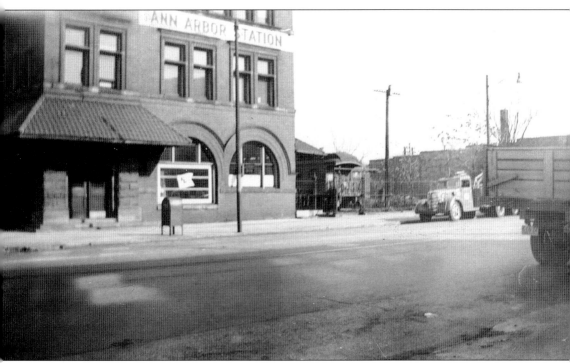

Here is the Ann Arbor Railroad Cherry Street Station c. 1950, with side tracks on which a passenger train is sitting. Two tracks ran beside the station-escape cross-over switches so the passenger engines could cut off and go the house to tie up after their runs. (G.W. Erhardt.)

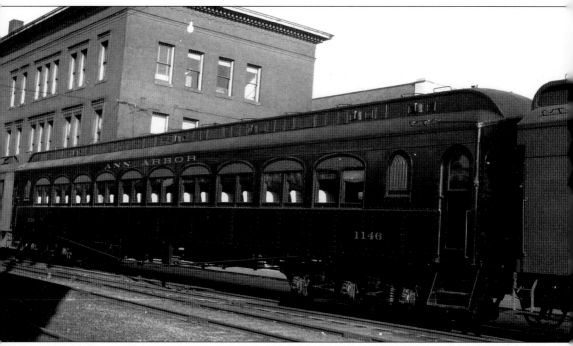

Ann Arbor coach No. 1146 sits at the Cherry Street Station waiting for departure, *c.* 1949. This wooden car had been a café car on the Ann Arbor and was converted into a day coach for use on 51 and 52, the Ann Arbor passengers to and from Frankfort, Michigan. The six-wheel trucks provided a really smooth ride. (R. Hubbard.)

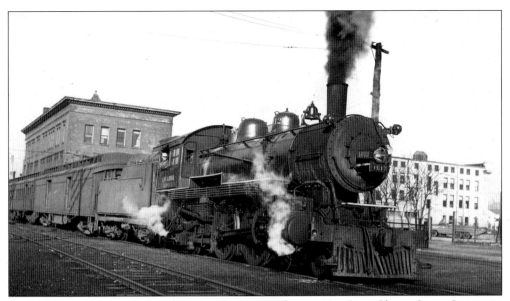

Here is the Ann Arbor Railraod EngineNo. 1612 with train No. 51 at Cherry Street Station in Toledo, c.1945. The Toledo Railfans Club took this train to Owasso, Michigan, and returned on the day this photo was taken. The back side of the Toledo Terminal Station is located to the right of the photograph. (R.V. Hubbard.)

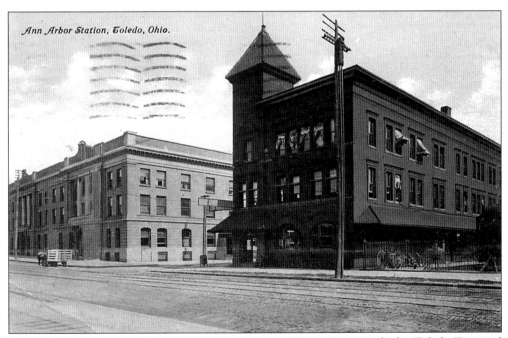

Ann Arbor Station, Toledo, Ohio.

Pictured here is the Ann Arbor Railroad Station on Cherry Street with the Toledo Terminal Station in the background. (Pulhuj collection.)

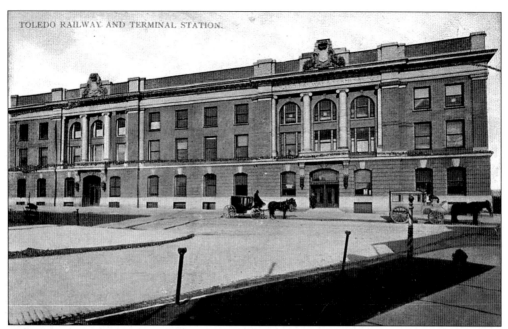

Here is view of the Toledo Railway & Terminal Station located on Cherry Street. (Pulhuj collection.)

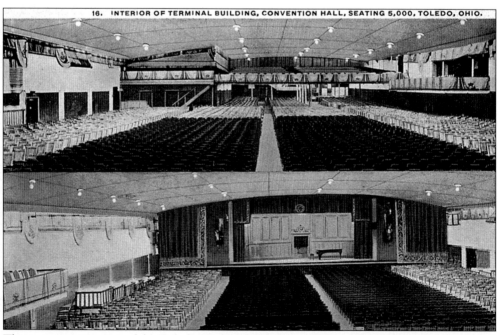

16. INTERIOR OF TERMINAL BUILDING, CONVENTION HALL, SEATING 5,000, TOLEDO, OHIO.

This is an interior view of the Toledo Terminal Station on Cherry Street, which was later used as a Convention Hall. Trade fairs and other exhibits were held here. (Pulhuj collection.)

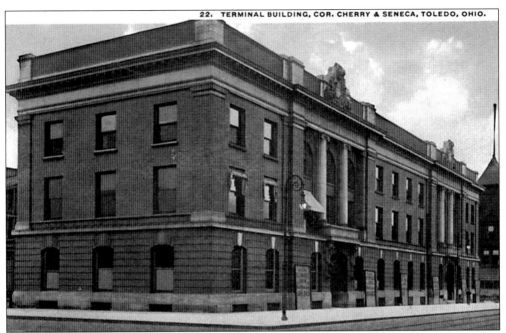

Seen here in 1969, the Toledo Terminal Station located on Cherry Street was used by Pere Marquette and Cincinnati, Hamilton & Dayton passenger trains in 1905. Later, the building was used for trade shows and exhibitions. Notice that the train sheds have been removed. (Pulhuj collection.)

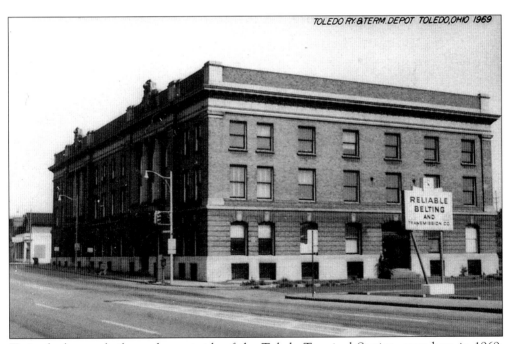

Train sheds were built on the east side of the Toledo Terminal Station, seen here in 1969. (Pulhuj collection.)

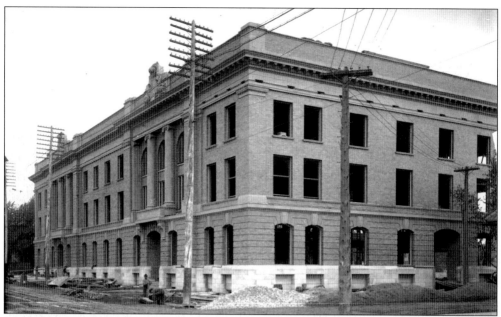

This is a *c.* 1903 photograph of the Toledo Railway & Terminal Station and Freight House located on Cherry Street. Notice that the building is still under construction. (Toledo Public Library.)

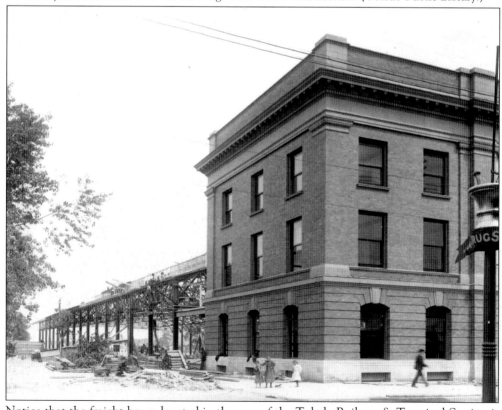

Notice that the freight house located in the rear of the Toledo Railway & Terminal Station is still under construction here, *c.* 1903. (Toledo Public Library.)

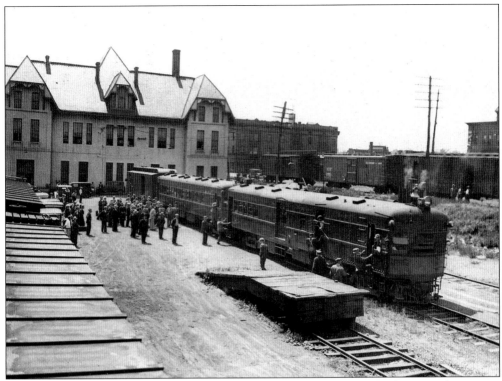

Seen here *c.* 1932 at the Cherry Street Station is the last run of the Wheeling & Lake Erie gas electric cars Nos. M102 and M103. Part of this building was later moved out to Homestead yard in East Toledo. (Toledo Public Library.)

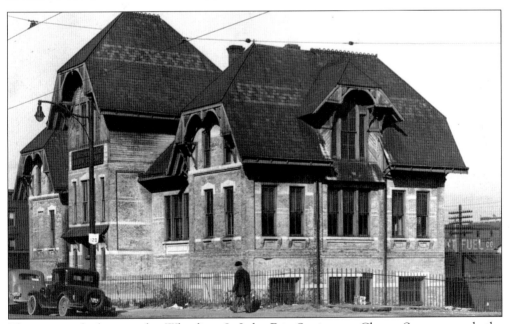

This view is looking at the Wheeling & Lake Erie Station on Cherry Street towards the northeast. (Pulhuj collection.)

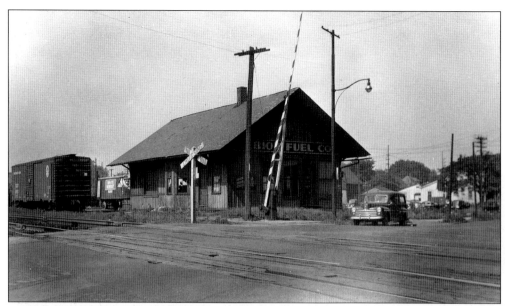

This New York Central Station on Dorr Street in Toledo was used for local service only. The Lake Shore & Michigan Southern Railroad originally built this station before the 1900s. This image was taken *c.* 1939. (W. Edson.)

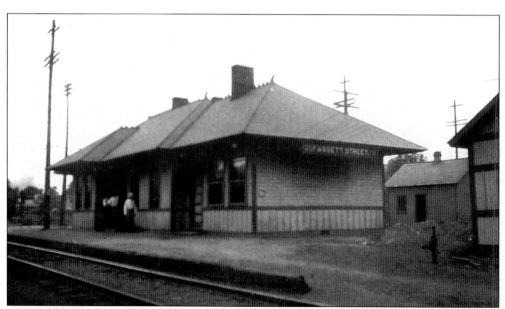

Toledo & Ohio Central Station is located in East Toledo at Fassett Street. This *c.* 1919 picture comes from the NYC 1919 valuation report. Passenger service would start from the Main Street station and stop just a mile down the line at this station. (Dr. M. Camp collection.)

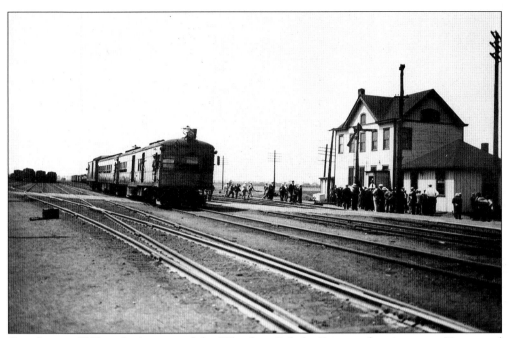

Seen here *c.* 1932 is the last run of the Wheeling & Lake Erie gas electric cars at Homestead Yard / Station in East Toledo. This building had been a part of the Cherry Street Station. (Toledo Public Library.)

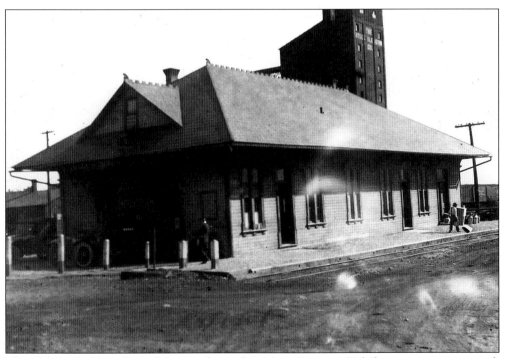

The Toledo & Ohio Central Station located at Main Street in Toledo was a station on stub tracks, as it was at the north end of the Toledo & Ohio Central's Maumee Yard. (Dr. Mark Camp collection.)

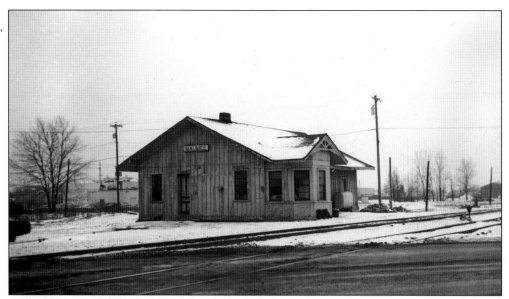

Pictured here c. 1968 is the Wabash Depot at Maumee. (K. Hise.)

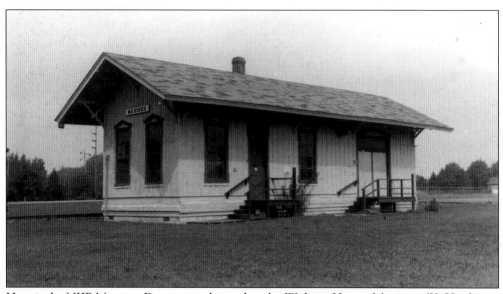

Here is the NKP Maumee Depot, now located at the Wolcott House, Maumee. (K. Hise)

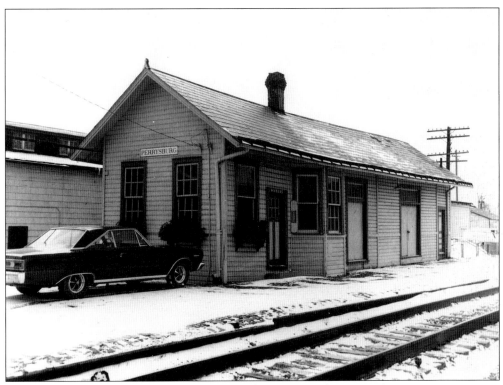

This is the Baltimore & Ohio Station at Perrysburg *c.* 1968. (B. Lorenz.)

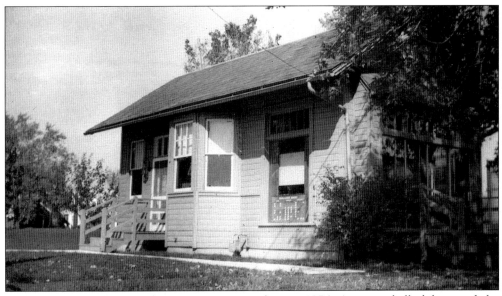

Here is the Baltimore & Ohio Station at Perrysburg *c.* 1976. A racquetball club moved the depot to the east side of town. (K. Hise.)

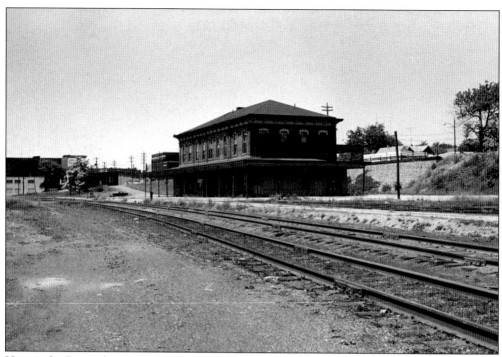

Here is the Pennsylvania Station located off of Summit Street, c. 1965. (O. Young.)

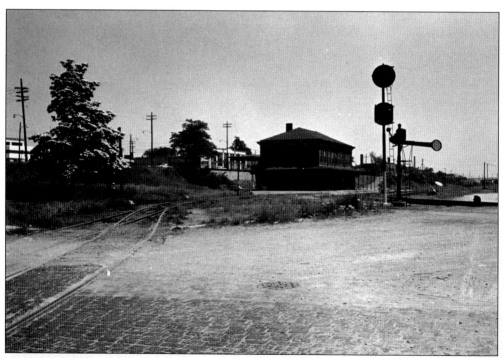

Note the signal and "smash board" guarding the Maumee River Bridge, c. 1965. The curve here onto the bridge had a five mile-per-hour speed limit. The operator's shanty was called "Olive." (O. Young.)

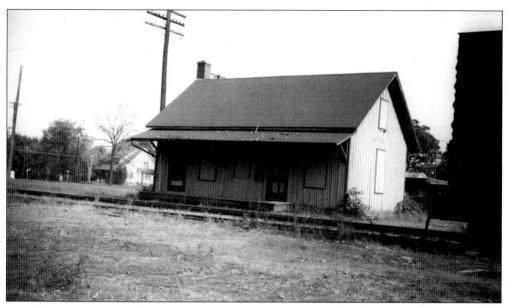

Here is a photograph of the NYC Depot at Sylvania, *c*. 1967. It has been moved into town and restored. (K. Hise.)

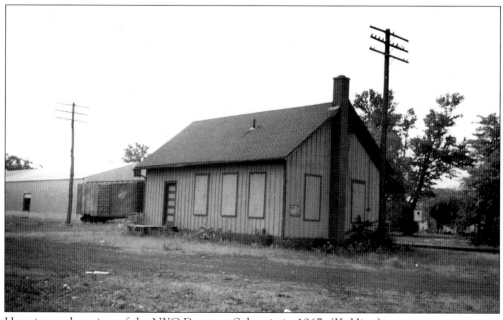

Here is another view of the NYC Depot at Sylvania in 1967. (K. Hise.)

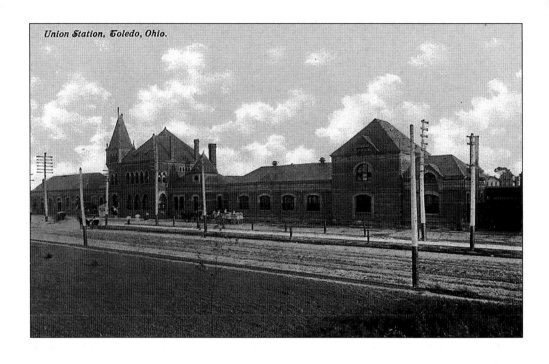

Union Station, Toledo, Ohio.

These two postcards show different views of Toledo's Union Station. (Pulhuj collection.)

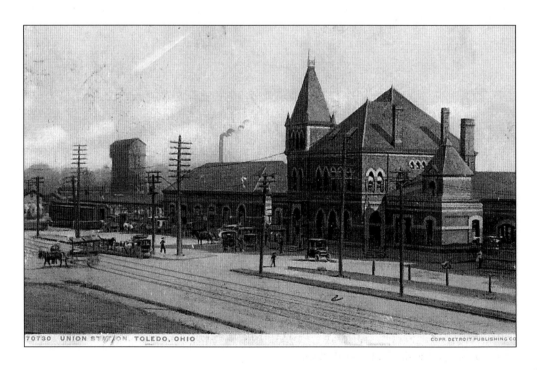

70730 UNION STATION. TOLEDO, OHIO. COPR. DETROIT PUBLISHING CO

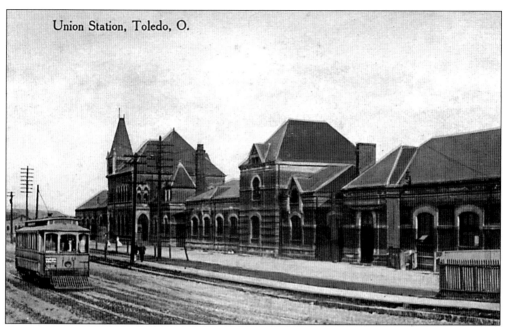

Union Station, Toledo, O.

Originally, a streetcar line looped in front of Union Station to pick up and drop off passengers. (Pulhuj collection.)

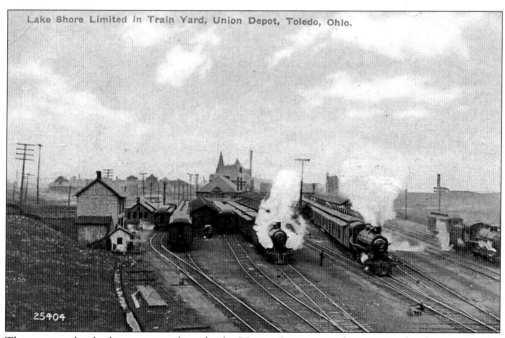

Lake Shore Limited in Train Yard, Union Depot, Toledo, Ohio.

25404

This postcard is looking eastward trackside. Union Station can be seen in the distance in the center of the postcard. (Pulhuj collection.)

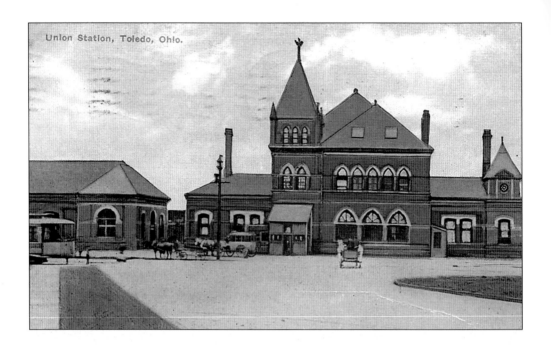

Here are two more views of Toledo's Union Station. (Pulhuj collection.)

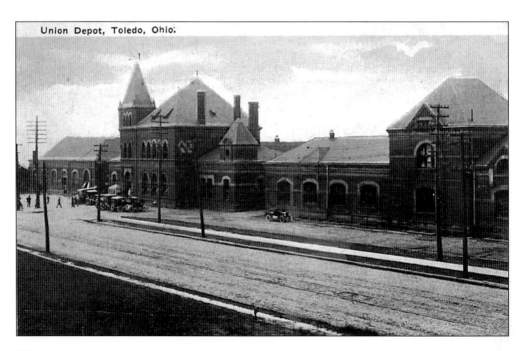

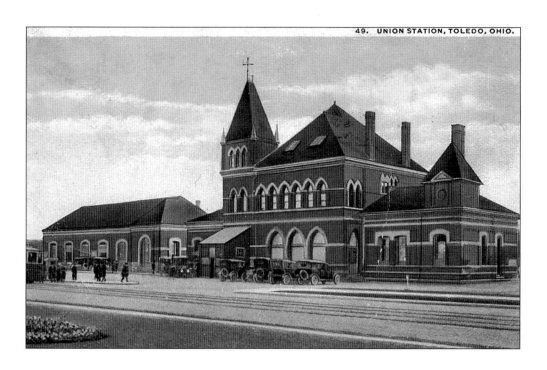

Notice the old cars lined up in front of Toledo's Union Station in these two postcards. (Pulhuj collection.)

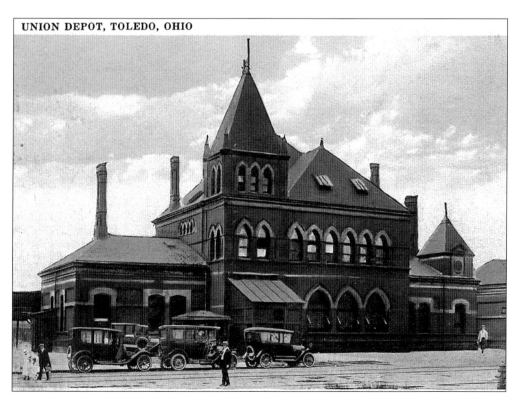

UNION DEPOT, TOLEDO, OHIO

61

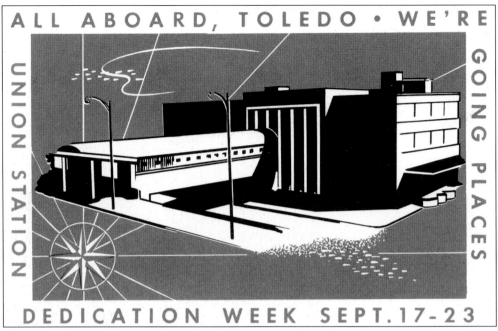

ALL ABOARD, TOLEDO • WE'RE

UNION STATION

GOING PLACES

DEDICATION WEEK SEPT. 17-23

This postcard was printed *c.* 1950 for the dedication week of the new Central Union Station. (Pulhuj collection.)

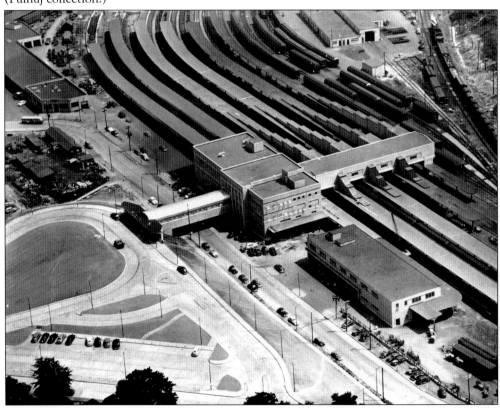

This is an aerial view of Central Union Station. (Pulhuj collection.)

In this *c.* 1949 photograph, NYC Engine No. 1632 passes the Union Central Station. Note the new station under construction. (B. Lorenz.)

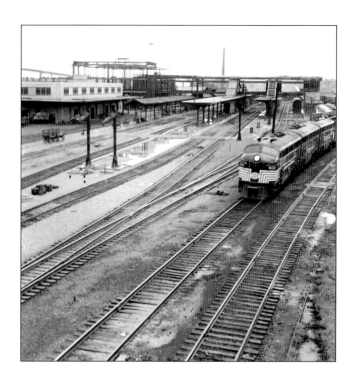

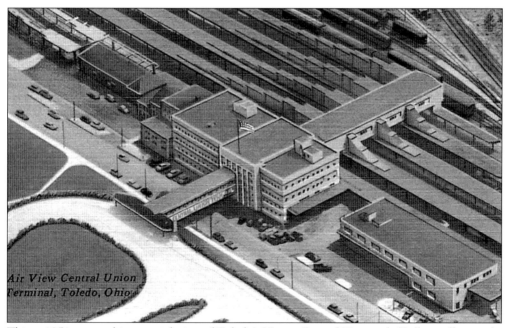

This *c.* 1951 postcard is an aerial view of Toledo's Union Central Terminal. (Pulhuj collection.)

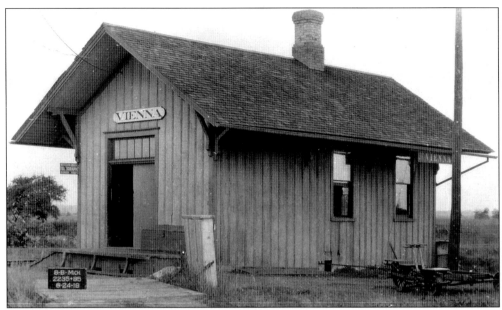

This c. 1919 photograph of the New York Central & Michigan Central Vienna Station is from a NYC evaluation report. Vienna was located north of the Alexis Tower and the state line. It was where the connection came out of the MC North Toledo Yards to the NYC and MC on the Detroit Division. The facing, or west, side of the building is NYC. The east side is lettered for MC. It has been said that the building was moved. The photograph of the building at Union Station may be of this station after it was moved. It has also been reported that an old retired NYC operator at an Erie, Michigan, station said that the Vienna Station had been taken to Toledo Union Station. (K. Hise collection.)

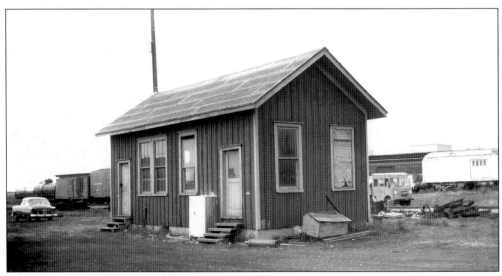

Here is the New York Central & Michigan Central Vienna Station c. 1957. This photograph was taken at Union Station. (K. Hise collection.)

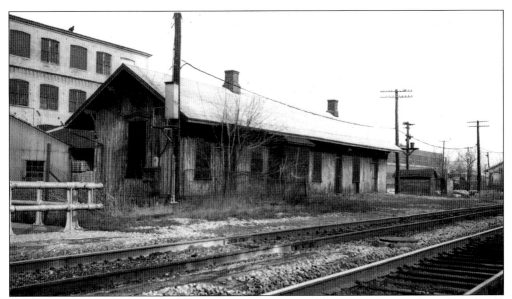

This Wagon Works passenger station, c. 1972, was located at the Monroe Street viaduct. It was closed for many years before it burned down in 1977. (K. Hise.)

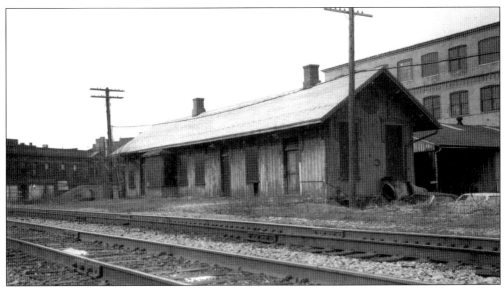

The Milburn Wagon Works, here, c. 1972, was located across from this station on the east side of the rails, hence the name "Wagon Works." The early Toledo baseball park, Swayne Field, was built on some of the Wagon Works property, and a small shopping area was opened on Monroe and Detroit Streets after the park was moved to the County Fair Grounds. (K. Hise.)

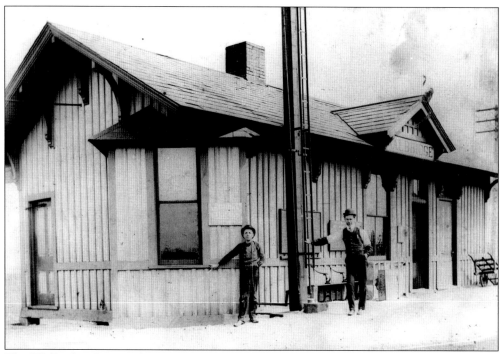

The Walbridge Station, here, c. 1898, was originally built by Pennsylvania Railroad. (K. Hise collection.)

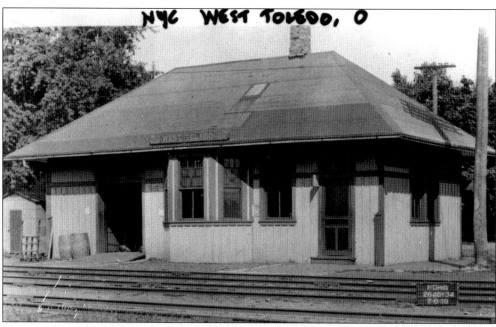

This station, shown here c. 1919, was originally built as a Canada Southern Station and was later transferred to Michigan Central and then to the New York Central Railroad. It was located on Sylvania Avenue in West Toledo. (Dr. Mark Camp collection.)

Six
INTERLOCKING, CROSSING TOWERS, AND WATER TANKS

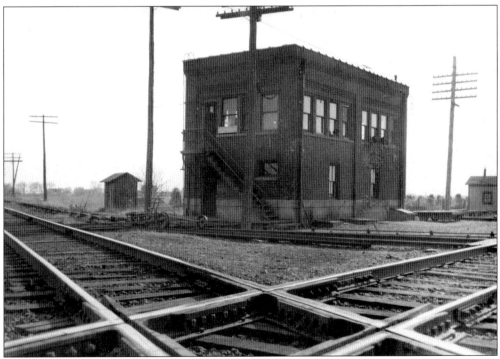

This c. 1921 photograph is of the Alexis Tower in Toledo. Note that the Ann Arbor tracks are located on the left and the Michigan Central / NYC on the right. (K. Hise collection.)

Tower Listings

Location	Railroads that intersected
Alexis	NYC / AA / MC / PM
Bancroft	Wabash
Bates	TT / B&O
Broadway	NYC / NKP
Broadway	Wabash / TRY&L
Boulevard	TT / AA
Copeland	NKP / TT
Fassett Street	NYC
Fitch	T&W / TT
Front St.	W&LE / NKP
Gould	Wabash
Hallet	AA / PM / PM
Ironville	W&LE / TT
JN	B&O / PCO / W&LE
K	NYC / TT / PM
Miami St.	PCO
Manhattan	W&LE / AA / O&MB
Millard	TT / C&O
Nasby	NYC / TT
Oak Dale	NYC
Ryan (No Tower)	TT / OPS
Shoreline Crossing	TT / D&TS
Stanley	NYC / TT / T&OC
Swan Creek	NYC /MC
Vickers	NYC / TT / BT/ TF&F
VR	CO
Vulcan	NYC / TA&W / T&I / TT
Wabash	Wabash / NYC
Walbridge	PRR / TT / C&O
West Toledo	NYC / CTC
Z	NYC / MC

(Note that this list contains all known towers at the time of this publishing.)

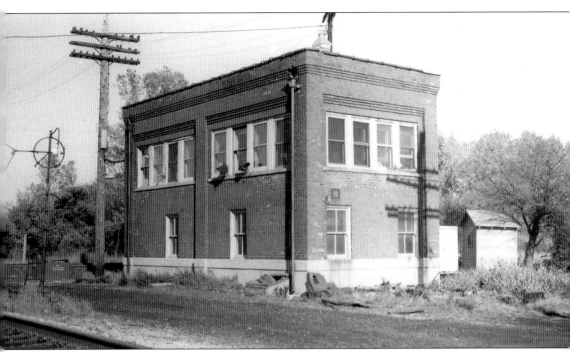

Alexis Tower was in North Toledo at the crossing of the Conrail, Ann Arbor Railroad, and the Chessie System tracks. It is seen here c. 1974. It was demolished in 1999. Earlier, a wooden tower stood at the Detroit, Monroe & Toledo Railroad in 1857 and the Toledo, Canada Southern & Detroit Railway in 1872. In 1871, the Toledo & Ann Arbor Railroad reached Alexis and made a connection with the Canada Southern line, which was later bought by Michigan Central. (K. Hise.)

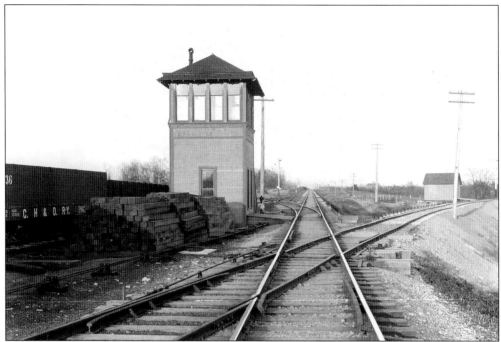

This c. 1902 photograph is looking north towards Rossford and shows the Bates Tower at the Toledo Terminal and Cincinnati, Hamilton & Dayton crossing on the west side of the tracks. Bates Tower was later built on the east side of the tracks. (Toledo Public Library.)

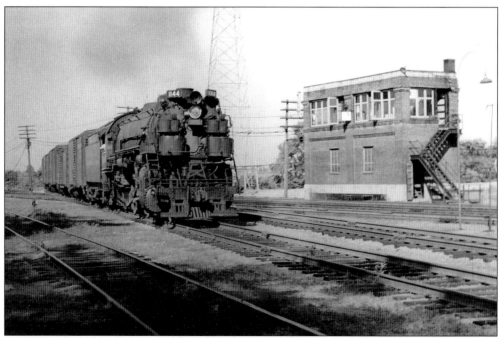

The Bates Tower was operated by the Toledo Terminal Railroad. In this photograph, you can see a C&O puller headed around Toledo Terminal Railroad with interchange delivery to one of the yards on the west side of Toledo via the Terminal. (B. Lorenz.)

70

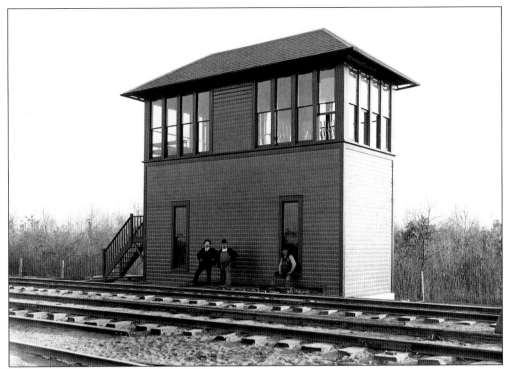

This is an unknown tower, c. 1902, found in the Toledo Terminal Railroad records. (Toledo Public Library.)

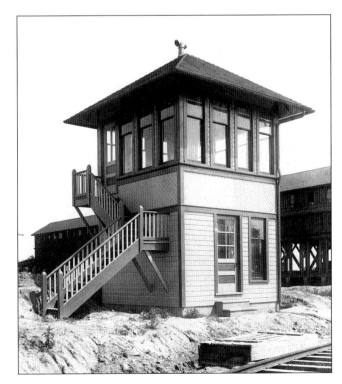

Toledo Terminal Railroad built this tower around the turn of the century. It is seen here c. 1902. Boulevard Tower and the coal facility are located in the background. (Toledo Public Library.)

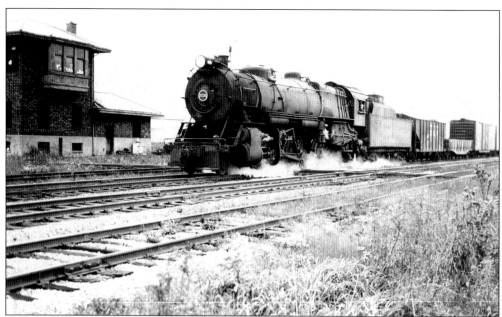

Here, Pennsylvania Railroad EngineNo. 7036 is heading south of Boulevard Tower at Manhattan Boulevard c. 1948. This was an Ann Arbor Tower, which lasted into the 1960s. (B. Lorenz.)

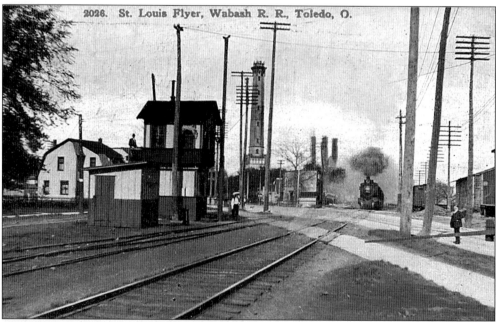

This is a photograph of a Wabash Railroad crossing watchman's tower on Broadway in 1911. In the background is the tower of the Toledo Waterworks. The Broadway Street Car line crossed the Wabash here, also the Toledo & Maumee Valley interurban ran on Broadway. This must have been a very dangerous crossing, especially as it is on an angle. In later years, a viaduct was installed here. August Glidemeister said he was hired in Rossford. He carried an 8-by-10 glass-plate camera up the water tower in the background. In later years, August repaired cameras and made many repairs for newspaper people in the area. (K. Hise collection.)

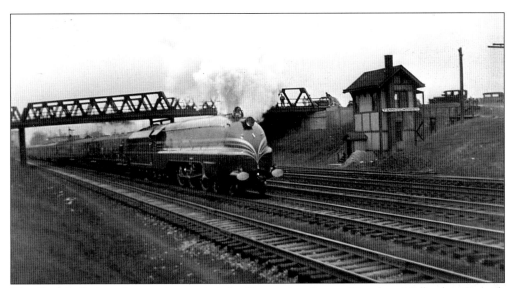

This English Railway locomotive carried the Coronation Scott of London, Midland & Scottish Railway, and traveled a total of 3121 miles on a U.S. tour in 1939. It then went to the Worlds Fair in New York City. Here, it is passing Fassett Street Tower on the New York Central on April 5th, 1939. It had been on exhibit at Toledo and was on its way to Cleveland. (F.D. Cairns.)

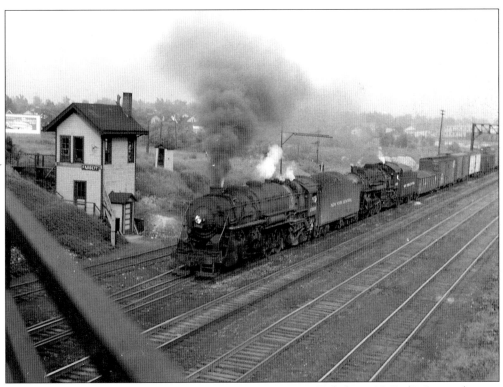

Here is a NYC westbound freight train at Fassett Tower in Toledo, c. 1948. (B. Lorenz.)

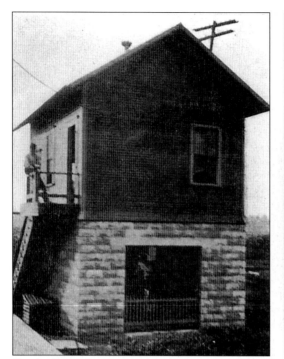

On the left is the Fitch Tower in West Toledo at the crossing of the Toledo & Western Railway and the Toledo Terminal Railroad, c. 1906. It was located along Tremainsville Road. On the right is Fitch Tower looking east, c. 1936. (K. Hise.)

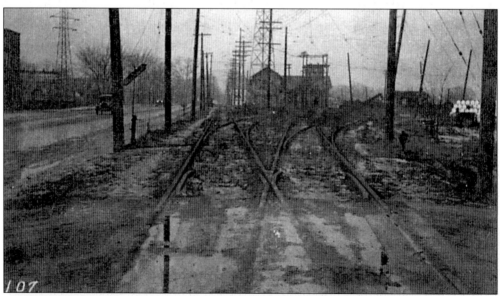

This view, looking west, also shows Fitch Tower c. 1936. The Toledo & Western had a yard here where autos from the Overland Automotive Company were loaded and shipped west for delivery to the Wabash Railroad. In later years, the Wabash bought the Toledo & Western. (K. Hise.)

74

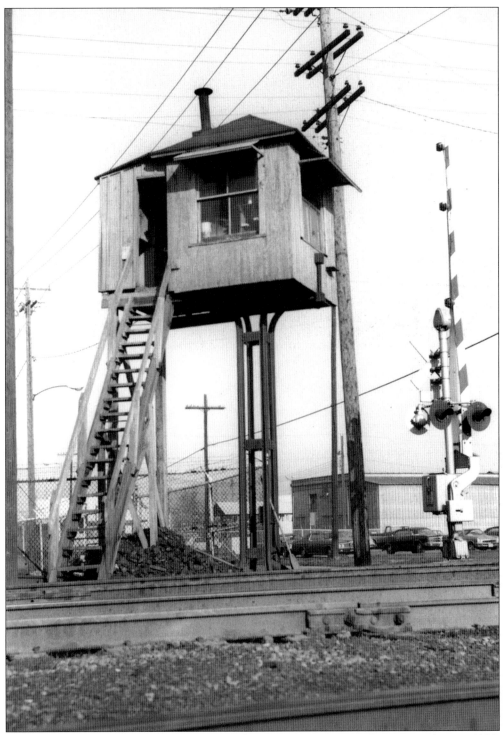

The old Wheeling & Lake Erie crossing watchman's tower on Front Street, seen here c. 1974, was located in East Toledo. This tower was removed and restored in Bellevue at the Mad River and NKP Museum. (K. Hise.)

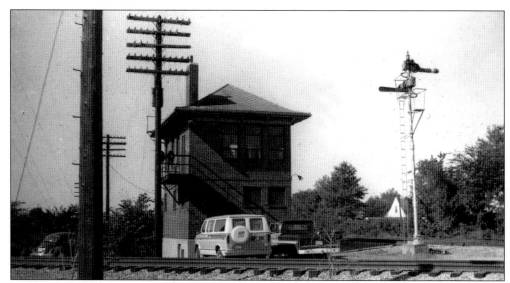

This is Gould Tower looking south *c.* 1977. It was at the crossing of the Toledo Terminal Railroad and the Nickel Plate and Wabash Railroads in South Toledo. The Ohio Electric Railway, later the Cincinnati & Lake Erie Railroad followed the NKP and Wabash and went into a tunnel under the Toledo Terminal Railroad at Gould. The C&LE ran through the cut by Bowser High School and crossed under Detroit Avenue in another tunnel. The concrete tunnels were buried under the Toledo Terminal Railroad and Detroit Avenue. They may still be there. (K. Hise.)

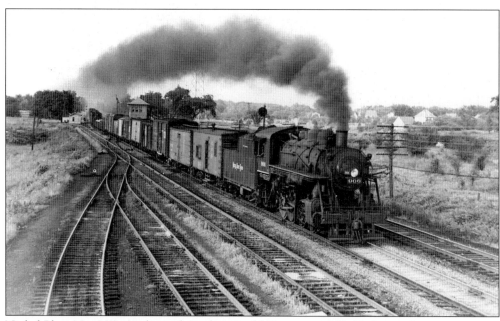

Nickel Plate No. 906 travels westbound at Gould Tower, *c.* 1947. (B. Lorenz.)

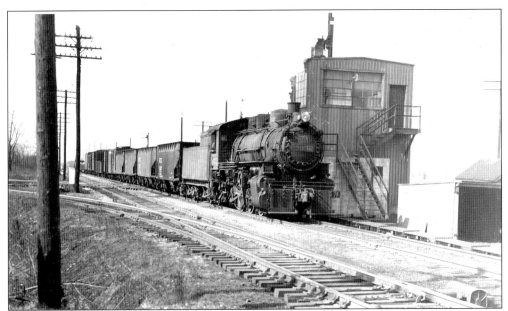

This is the Wheeling & Lake Erie EngineNo. 3952 with a transfer run from Pere Marquette to Ottawa Yard and is southbound at Hallet Tower, crossing the Toledo Terminal Railroad, c. 1949. (Bob Lorenez.)

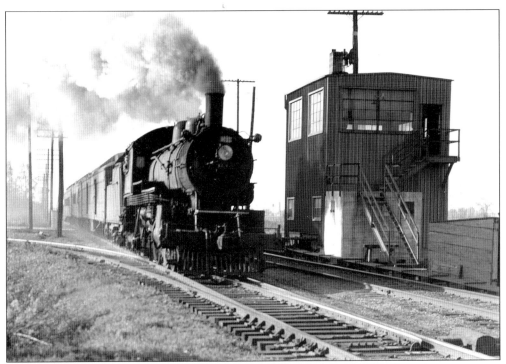

This is the Ann Arbor No. 1612, Atlantic-type locomotive with No. 52 passenger train at Hallet Tower heading south bound towards Cherry Street Station and the end of the line, c. 1949. This tower is operated by the Ann Arbor Railroad and is still in operation at the time of the writing of this. It is located on Matzinger Road in North Toledo. (B. Lorenz.)

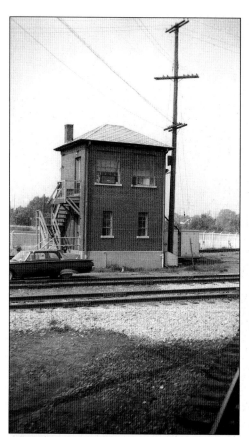

Ironville Tower is shown here c. 1970 in East Toledo at the crossing of the Toledo Terminal Railroad and Norfolk Southern Railroad. This tower is located just west of the Presque Isle and Lake Front docks of the CSX System and is operated by Norfolk & Southern Railroad. (K. Hise.)

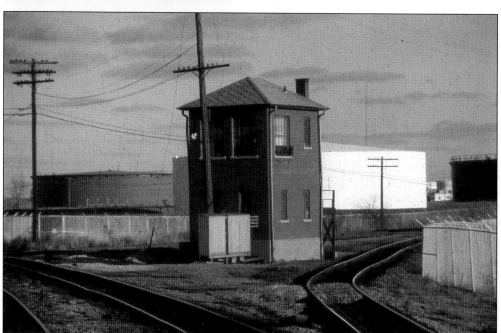

Here is another photograph of the Ironville Tower, c. 1981, looking south. (K. Hise.)

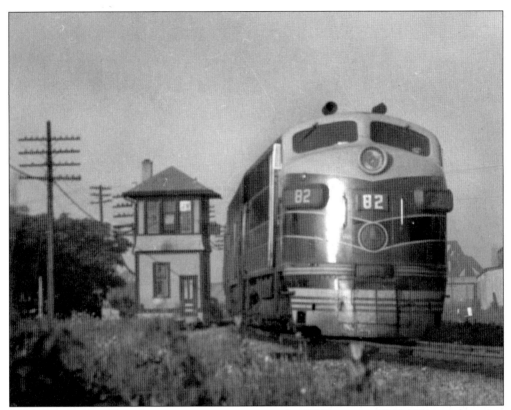

B&O Engine No. 82 with a passenger train passes the JN Tower, c. 1947. This tower was at the east end of the Baltimore & Ohio Rossford Yard and controlled moves to the Wheeling Belt and the NYC main line. Also a connection to the Pennsylvania Railroad was made here. (G.W. Erhardt.)

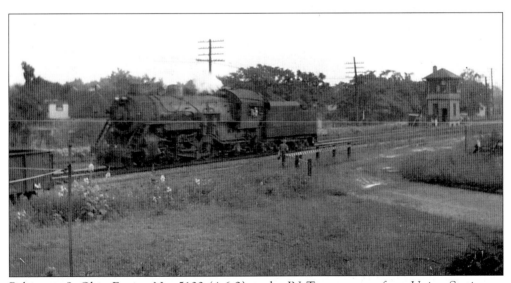

Baltimore & Ohio Engine No. 5100 (4-6-2) at the JN Tower comes from Union Station, c. 1947. (G. W. Erhardt.)

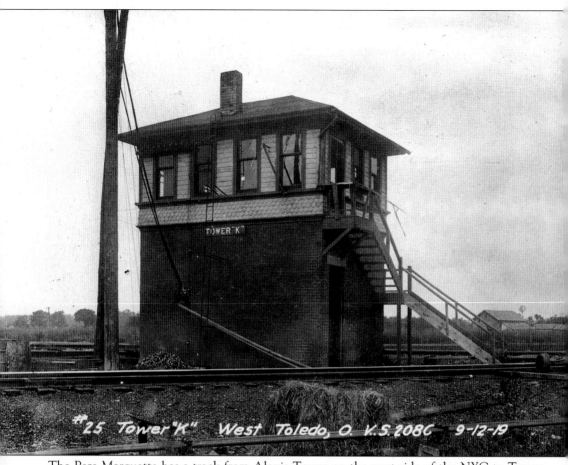

#25 Tower "K" West Toledo, O. V. S. 2086 9-12-19

The Pere Marquette has a track from Alexis Tower on the west side of the NYC to Tower K. Here, c. 1919, a connection was made to the Toledo Terminal Railroad going west on Direction A. Pullers to the NKP and B&O often ran this way. The connection switch was protected by a pipe-connected derail. Over the years, many locomotives and also cabooses were derailed here. This photograph is from the NYC evaluation report of September 12, 1919. (Dr. Mark Camp collection.)

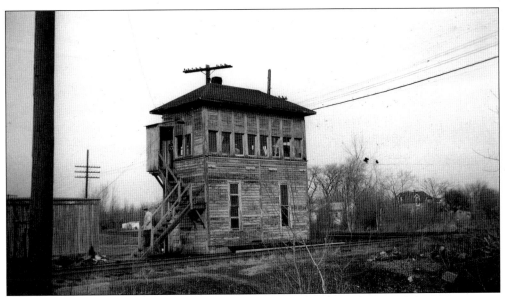

F.D. Cairns is seen on the steps of the Manhattan Tower, c. 1964. (K. Hise.)

Manhattan Tower was located in North Toledo. This tower, seen here c. 1964, stood at the crossing of the Ann Arbor Railroad and the Wheeling & Lake Erie Railroad. The Ohio & Michigan Belt rail was on the west side of the tower. (K. Hise.)

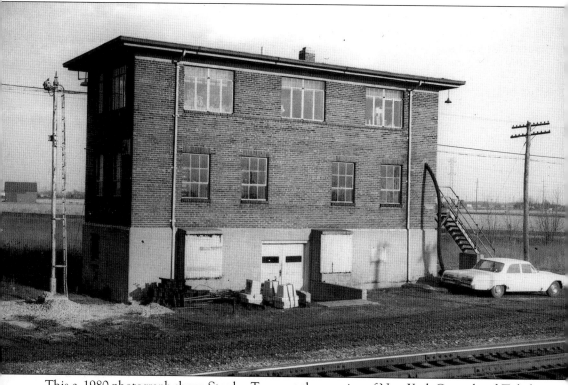

This c. 1980 photograph shows Stanley Tower at the crossing of New York Central and Toledo Terminal Railroad near Walbridge Yard, located west of East Broadway. The tower also controls movements on the former Toledo & Ohio Central Western Line through Bowling Green and on south. It is now owned and operated by CSX. (K. Hise.)

Swan Creek Tower of the New York Central Railroad was located at the east end of Air Line Junction, where the Michigan Central Line from Detroit joins the New York Central Line. The tower is seen here c. 1969. (K. Hise.)

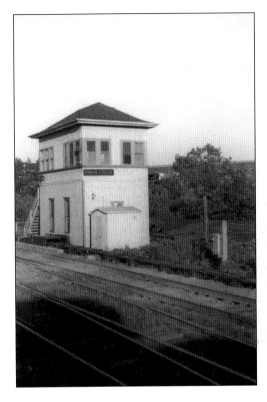

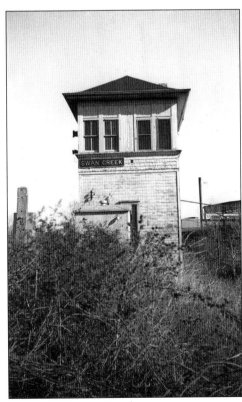

Swan Creek Tower is seen again here, c. 1973. (K. Hise.)

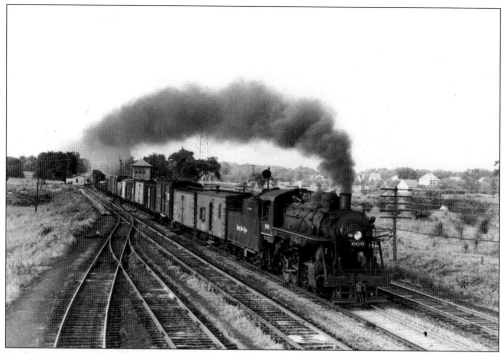

Vickers Tower is located in the background with C&O Engine No. 1560 heading towards Walbridge Light, c. 1949. Vickers was located near the crossing of Wales Road and Droulard Road in Northwood. (B. Lorenz.)

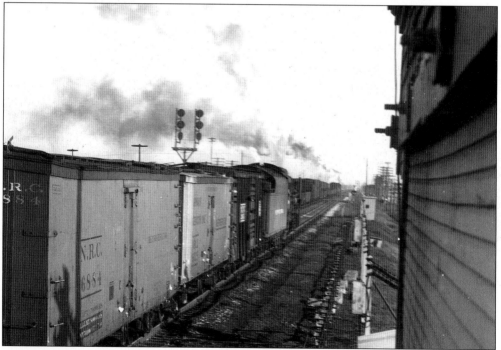

Two trains are passing Vickers Tower in this c. 1949 photograph taken from the steps of the tower looking east. (B. Lorenz.)

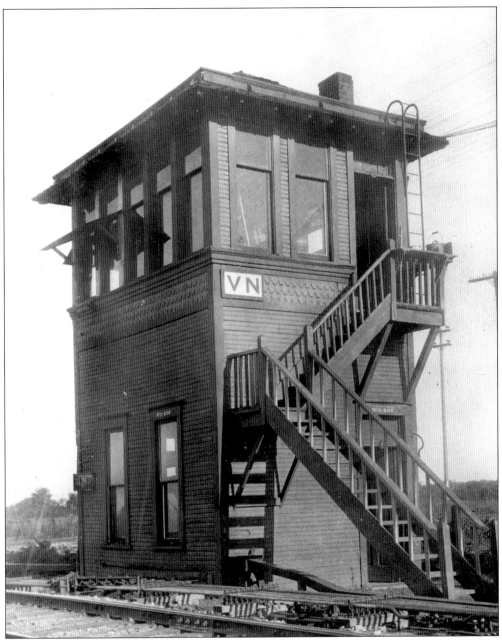

New York Central's Vulcan Tower, located at Dorr and Westwood, is seen here around 1919. This tower controlled the movements of the New York Central, Toledo Terminal, Toledo Angola & Western, and Toledo & Indiana Railroads. (B. Lorenz.)

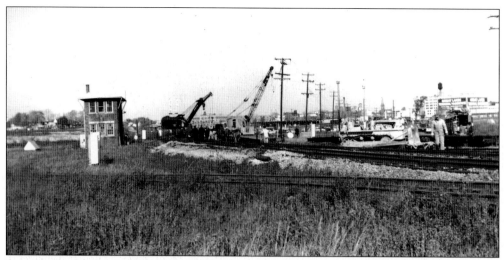

Repair crews clean up after a New York Central train wreck at Wabash Tower, c. 1959. The tower is near the Toledo Union Station. The Wabash and New York Central rail lines crossed here. (K. Hise.)

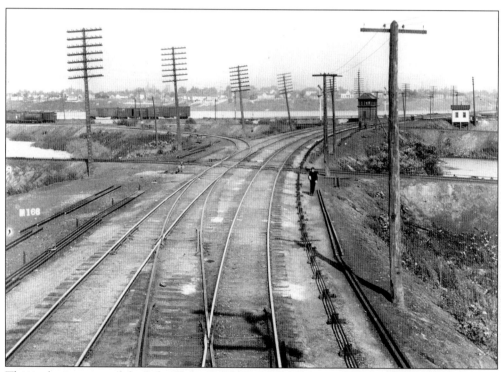

This is the junction of the Lake Shore & Michigan Southern and Wabash Railroads at Union Station, c. 1906. Notice Wabash Tower in the background. (B. Lorenz collection.)

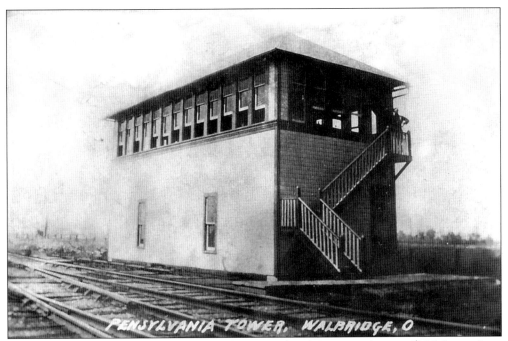

Walbridge Tower was built by the Pennsylvania Railroad. It is seen here c. 1916. It was later replaced by the brick structure found below. (K. Hise collection.)

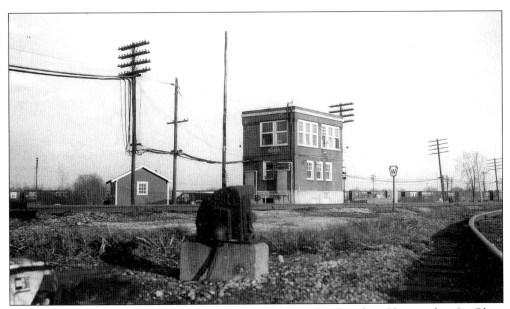

Walbridge Tower, seen here c. 1970, controlled traffic for the Chesapeake & Ohio, Pennsylvania, and Toledo Terminal Railroads. (K. Hise.)

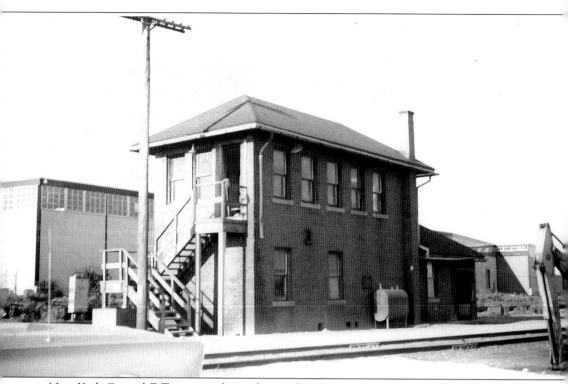

New York Central Z Tower was located at Airline Junction on the east side of the yard. It is seen in this photograph around 1973. This tower was demolished by a freight train wreck on February 17, 1974. (K. Hise.)

This photograph shows Toledo Railway & Terminal Boulevard Yard Water Tank c. 1903. (Toledo Public Library.)

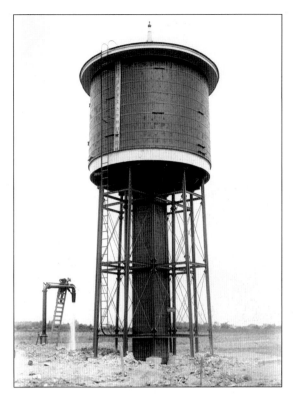

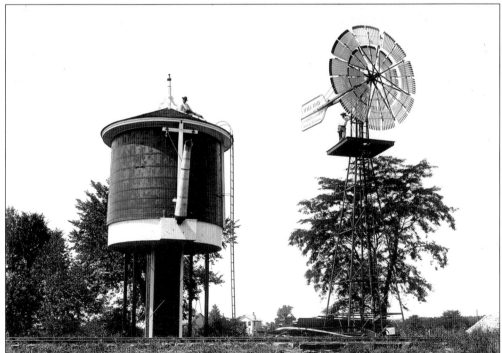

Here is the Miami & Erie Canal Water Tank near Copeland Tower, c. 1903. (Toledo Public Library.)

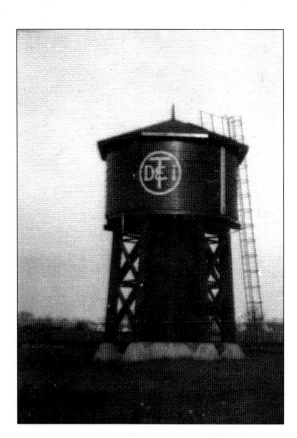

Here is the Detroit, Toledo & Ironton Water Tank at Temperance Yard on Laskey Road, c. 1950. (R. Hubbard.)

Form 450

THE TOLEDO TERMINAL RAILROAD COMPANY

Date_____, 19____

Received from the Toledo Railroad Co.

At Boulevard _____tanks water

At Vulcan _____tanks water

At Consaul Street_____tanks water

Engine, Initial_____Number_____

En route from_____R. R. to_____R. R.

Engineman_____

This is a receipt for Wabash Engine No. 2737 taking a tank of water at the Vulcan Water Tank on November 12, 1940. Puller crews taking water on the Toledo Terminal were expected to register this use. This slip shows that there were tanks at Boulevard, Vulcan, and Consaul Street in the days of steam. (K. Hise collection.)

Seven

FREIGHT HOUSES AND YARD OFFICES

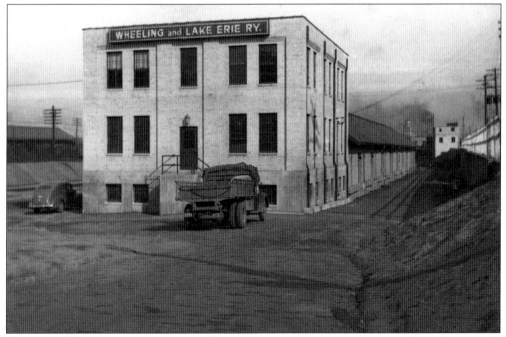

This is the Wheeling & Lake Erie Freight Station on Cherry Street, c. 1946. The Wheeling & Lake Erie track leading into North Toledo was built in the bed of the abandoned Miami & Erie Canal. (G. Erhardt.)

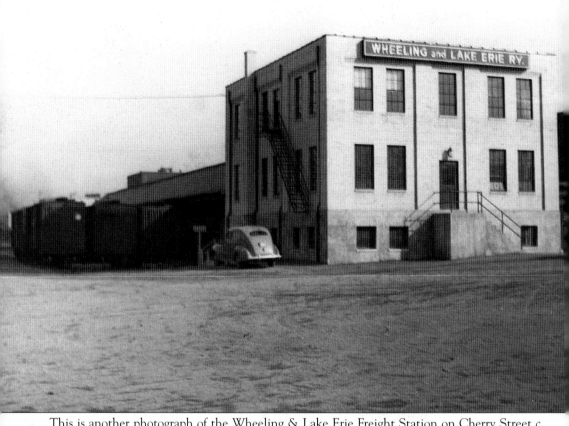

This is another photograph of the Wheeling & Lake Erie Freight Station on Cherry Street *c.* 1946. (G. Erhardt.)

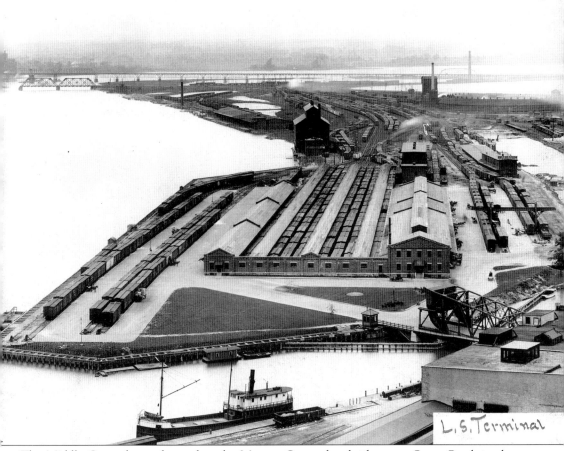

L.S.Terminal

The Middle Grounds was located at the Monroe Street drawbridge over Swan Creek in the foreground, *c.* 1915. The NYC freight house and offices are in center. The B&O freight house can be seen in the right center. Lower engine house facilities and the roundhouse are in the upper right corner. The Wabash railroad also had a freight house here. In the back rear, the New York Central Maumee Bridge and the Fassett Street Bridge for automobiles can be seen. The freight yard complex was called Pileing Yard. Author K. Hise rode a New York Steam switcher here one night in July 1946. Engine crews for the road trains bunked in the Lower House. The Dayton & Michigan, predecessor of the Baltimore & Ohio, had a roundhouse here at one time as well. The Lake Shore & Michigan Southern Island House Station was here also. (Toledo Public Library.)

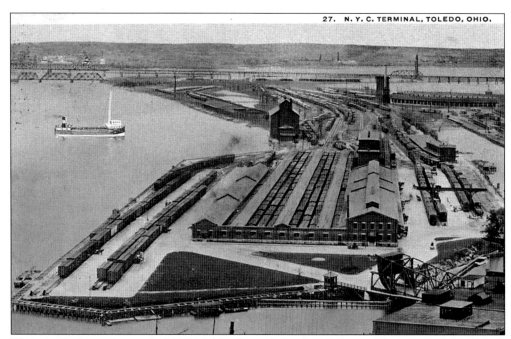

This view looks south over the NYC Middle Grounds freight operations. There is a jack-knife draw bridge over the Swan Creek River at the foot of the Monroe Street. A small boat used Swan Creek at this time and was the entrance to the Miami and Erie Canal. (Pulhuj collection.)

Aerial View of Toledo, Ohio

This view looks north over the NYC Middle Grounds freight operations. (Pulhuj collection.)

This *c.* 1975 photograph shows the Toledo & Ohio Central Freight House on Main Street in International Park in Toledo. (K. Hise.)

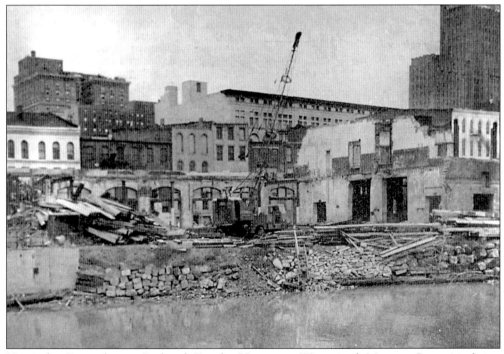

Here, the Pennsylvania Railroad Freight House on Water and Monroe Streets is being demolished. This building was built as a streetcar barn by Toledo Traction.

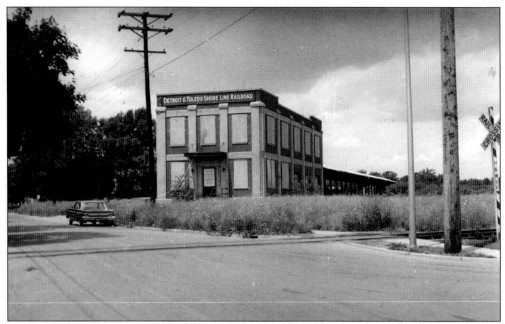

This is the Detroit & Toledo Shore Line Freight House in North Toledo on New York Avenue, c. 1970. The rail line operated a car train from here out to Lang Yard for employees in the early days. (K. Hise.)

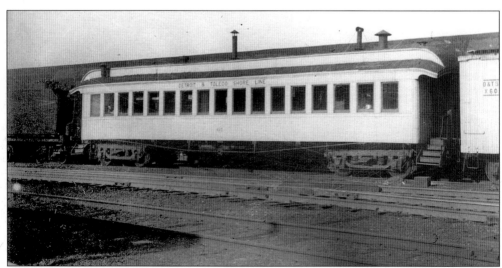

This is the Detroit & Toledo Shore Line Employee's Car at Lang Yard, c. 1939. This would have been one of the cars that ferried employees from the York Street Freight House to Lang Yard and back. (G. Erhards.)

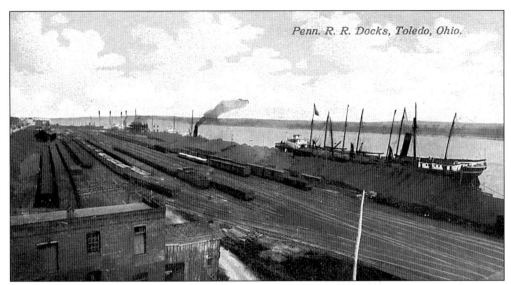

Penn. R. R. Docks, Toledo, Ohio.

This c. 1900 view is from atop the passenger station showing the Pennsylvania Freight Yard and Docks along the Maumee River. The coal and iron ore docks were operated by the Columbus, Hocking Valley, and Toledo Railway (later the Hocking Valley Railway). They were abandoned soon after the turn of the century. (Pulhuj collection.)

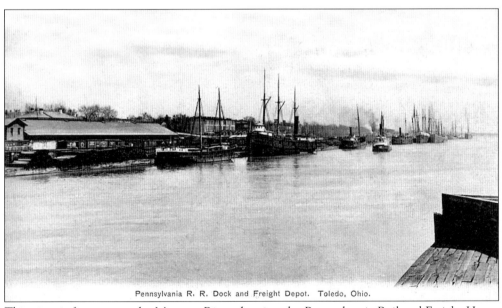

Pennsylvania R. R. Dock and Freight Depot. Toledo, Ohio.

This view is from across the Maumee River showing the Pennsylvania Railroad Freight House and water front docks. The Freight House was built in 1879. (Pulhuj collection.)

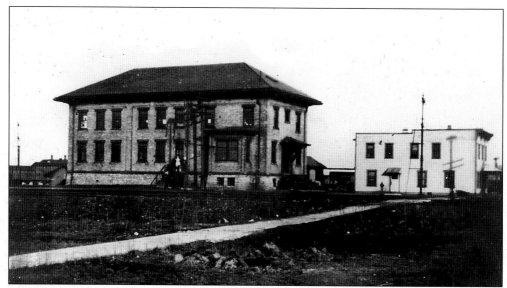

The Hocking Valley office at Walbridge on Union Street is seen in this c. 1920 photograph. A duplicate of this building stood in Columbus, Ohio. This building lasted into the C&O days and was demolished in the 1980s. (K. Hise collection.)

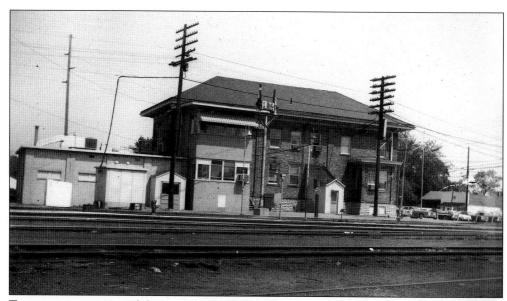

Train crews went to work here, at the Walbridge "Brick." Clerks and officials had office space here. There was a telephone office on the first floor for the many yard phones. The train order operator had an office on the left of the building at trackside. This building was the nerve center for Walbridge Yard operations. This photograph was taken around 1980. (K. Hise.)

Here are DT&I offices at Temperance Station in West Toledo on Lasky Road, c. 1962. This building had been the engine house for the Toledo Detroit Railroad. An Armstrong turntable was located here. (Armstrongs worked using a manually-operated table.) The track to the left of the building at one time crossed Lasky Road and extended down to Sylvania Avenue. In early days, the Toledo, Ann Arbor & Jackson Railroad (Ragweed) passenger train terminated on the north side of Sylvania Avenue. There was intent to cross that street, but the rails were never extended. (K. Hise.)

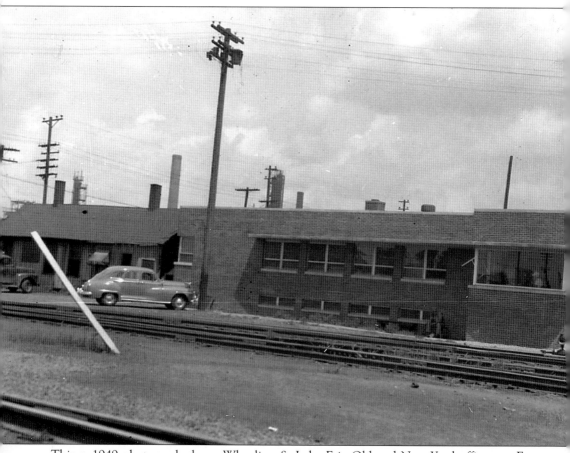

This *c.* 1949 photograph shows Wheeling & Lake Erie Old and New Yard offices on Front Street in East Toledo. A wooden building was built *c.* 1889 just to the left of the new brick structure. (G. Erhardt.)

Eight
FREIGHT YARDS

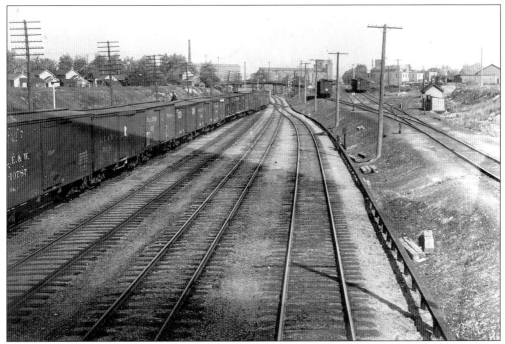

This is the New York Central Yard at Fassett Street in Toledo, c. 1906. The Toledo & Ohio Central Yard is to the right on top of the hill. (B. Lorenz.)

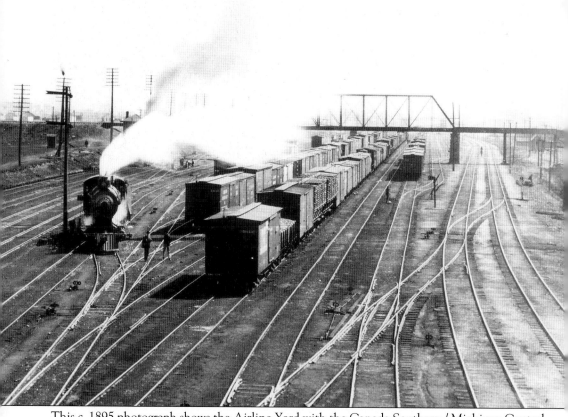

This *c.* 1895 photograph shows the Airline Yard with the Canada Southern / Michigan Central overpass in the background. Canada Southern was later controlled and incorporated by Michigan Central. (B. Lorenz collection.)

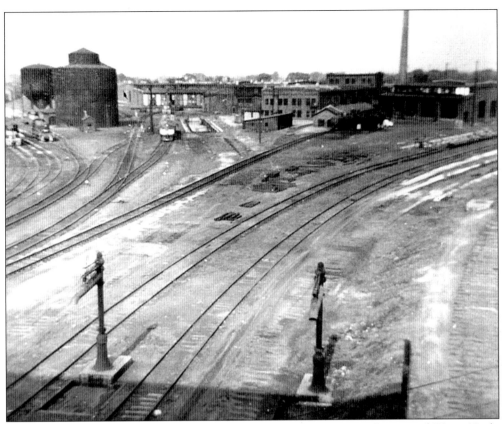

This photograph shows the New York Central Airline Junction Roundhouse and Water Tank, c. 1950. (B. Lorenz.)

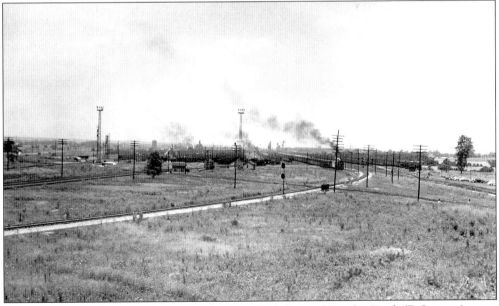

This c. 1968 view looks south towards the New York Central Stanley Yard. (B. Lorenz.)

This is an aerial view of Detroit & Toledo Shoreline Lang Yard, looking north, about 1920. Notice the Ottawa River in the background. (Toledo Public Library.)

This aerial view of Detroit & Toledo Shoreline Lang Yard is looking south, around the same time, 1920. Notice that Interstate 75 is not yet built, to the left—there are just fields. (Toledo Public Library.)

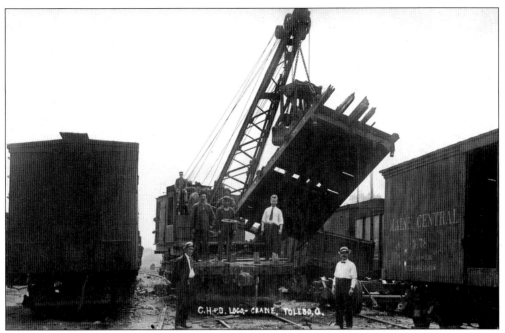

This is a wrecking crane on the Cincinnati, Hamilton & Dayton Railroad at the Maumee River Yard. (Pulhuj collection.)

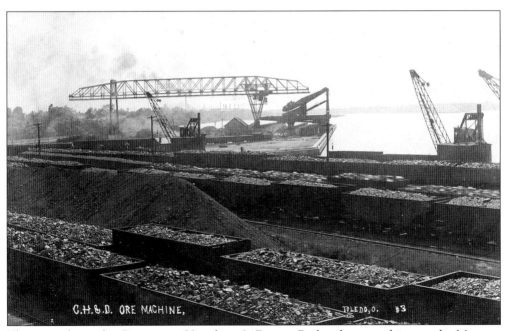

This view shows the Cincinnati, Hamilton & Dayton Railroad ore machine on the Maumee River. Later named the CH&D, it was bought out and controlled by the Baltimore & Ohio Railroad. (Pulhuj collection.)

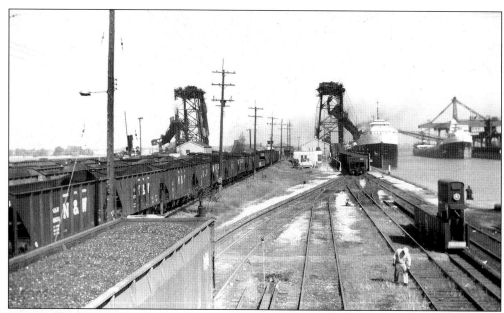

Here are the Chesapeake & Ohio Presque Isle Docks with coal machines nos. 2, 1, and 4 in the background, c. 1961. The belt machine, no. 4, can be seen in this photograph on the extreme right. This is the only machine left at the PI Docks. (K. Hise.)

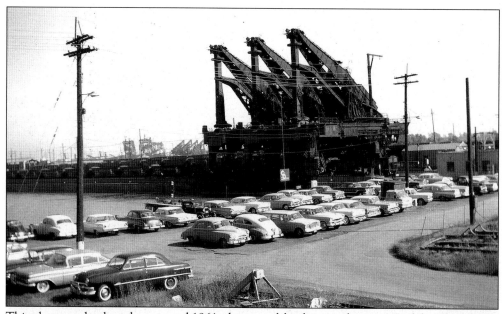

This photograph, also taken around 1961, shows coal-loading machine no. 3 of the Chesapeake & Ohio at the Presque Isle Docks. These machines were the three Hulet iron ore unloading machines. They are gone now. Today, ore boats self-unload onto the ground at the former Lake Front Docks. (K. Hise.)

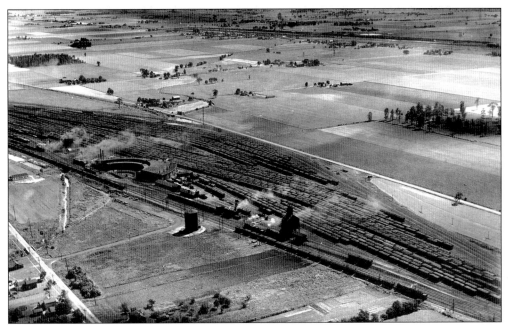

This is a c. 1945 aerial view of Walbridge Yard, which was operated by the Chesapeake & Ohio Railroad. (Toledo Public Library.)

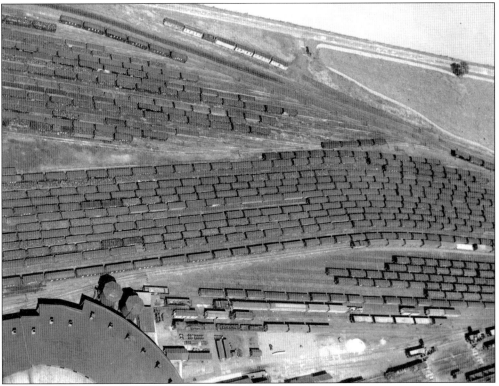

This c. 1945 aerial view of Walbridge Yard shows the roundhouse and freight classification yard. (Toledo Public Library.)

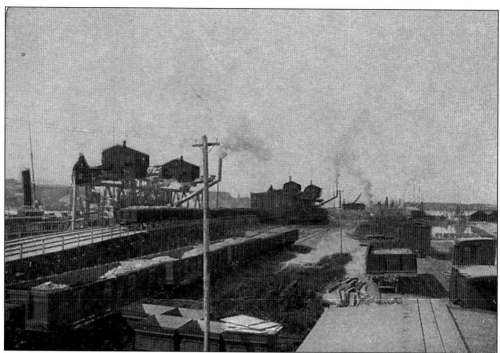

The Toledo & Ohio Central Maumee River Yard and coal docks are seen here. (Pulhuj collection.)

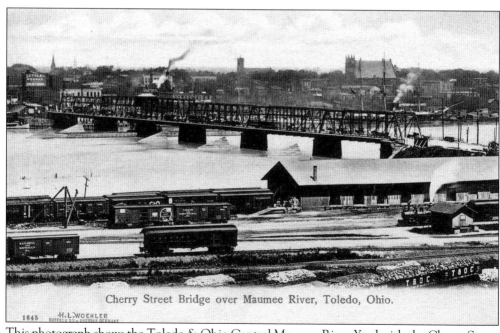

Cherry Street Bridge over Maumee River, Toledo, Ohio.

This photograph shows the Toledo & Ohio Central Maumee River Yard with the Cherry Street Bridge in the background. Notice the freight house in the center right just off of Main Street. (Pulhuj collection.)

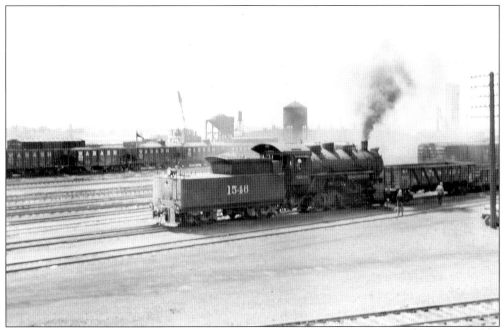

Here is the Wabash Maumee River Yard with Engine No. 1546 handling freight in the yard, *c.* 1948. (B. Lorenz.)

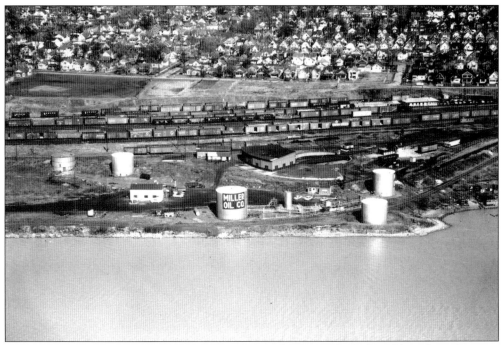

This aerial view shows Wabash's Maumee River Yard *c.* 1948. (Toledo Public Library.)

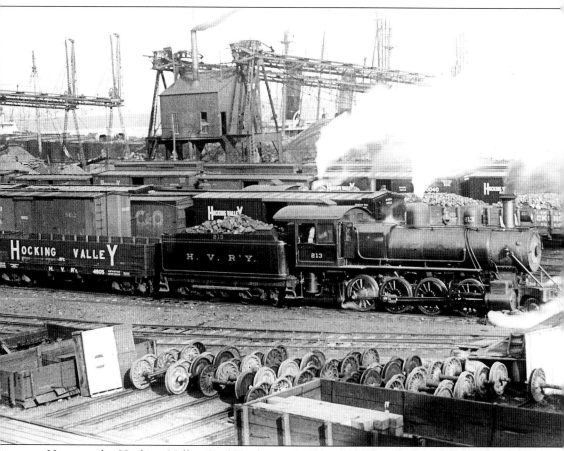

Here are the Hocking Valley Coal Docks on the Maumee River. Later Chesapeake & Ohio would purchase this rail line. These docks were on the north side of the river at the Pennsylvania Railroad Station. Slips replaced them, as well as two coal machines on the east side of the river, a little farther downstream toward the lake. They, in turn, were dismantled when the Chesapeake & Ohio developed coal facilities on the Maumee Bay at Presque Isle. (B. Lorenz.)

Nine
LOCOMOTIVES

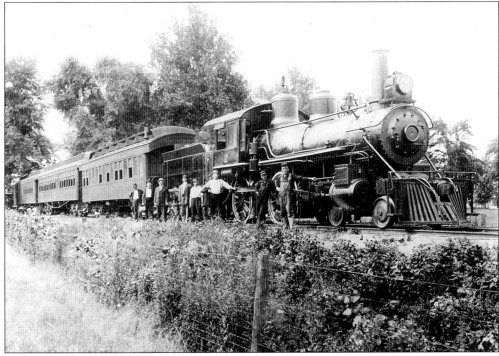

Toledo, Ann Arbor & Jackson Engine No. 2 sits at Sylvania Avenue in West Toledo *c.* 1916. This line ran from West Toledo to Petersburg, Michigan. There was probably no station at this end of track. The TAA&J later became the Detroit, Toledo & Ironton Railroad branch into Toledo around 1918. (G. W. Erhardt.)

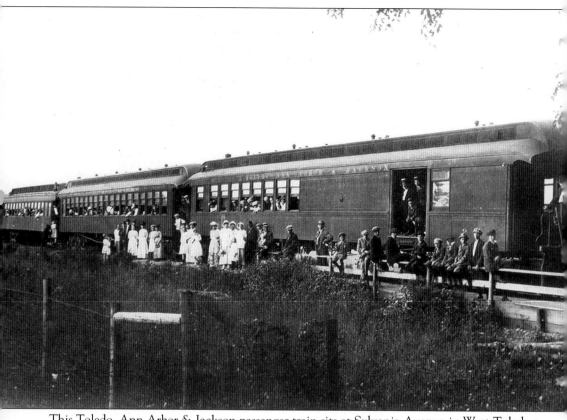

This Toledo, Ann Arbor & Jackson passenger train sits at Sylvania Avenue in West Toledo *c.* 1916. (K. Hise collection.)

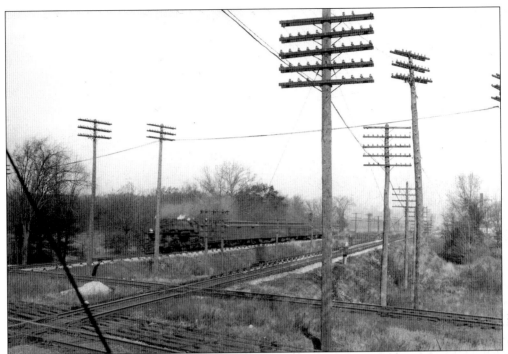

This New York Central passenger train heads southbound at Alexis Tower, c. 1930. (K. Hise collection.)

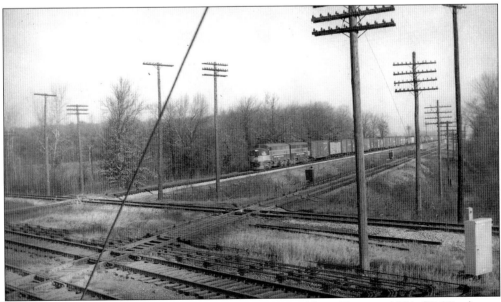

Here is a southbound New York Central freight train at Alexis Tower c. 1954. (K. Hise.)

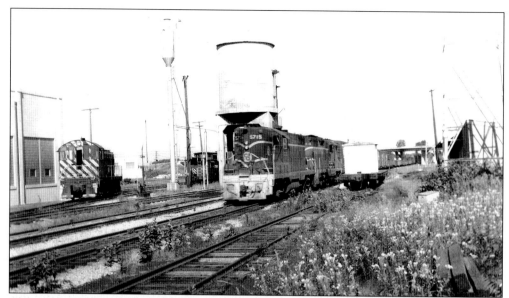

Chesapeake & Ohio's Engine No. 5715 passes Toledo Terminal's Engine House at Boulevard Yard around 1962. Toledo Terminal's Engine No. 106 is see at right in this photograph. (K. Hise.)

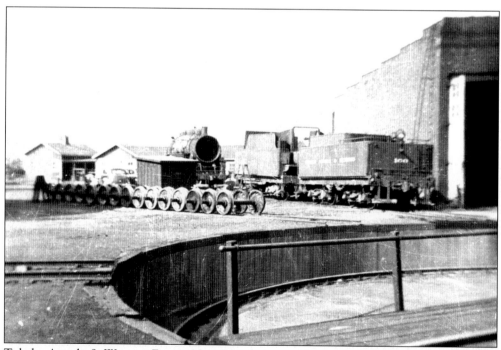

Toledo, Angola & Western Engine No. 100 is being repaired at Toledo Terminal's Boulevard shops. (R. Hubbard.)

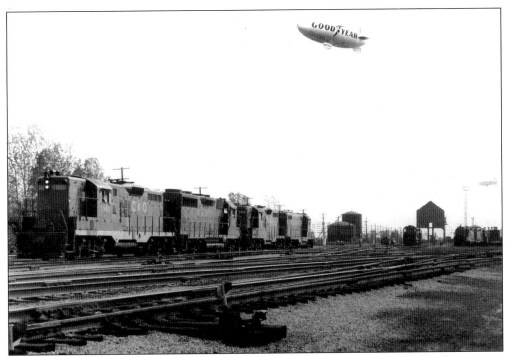

Chesapeake & Ohio Engine No. 5998, along with other general purpose early diesel engines at Walbridge Yard, ready for trains in 1980. Crews would take their power from here and go procure north or southbound trains. (B. Lorenz.)

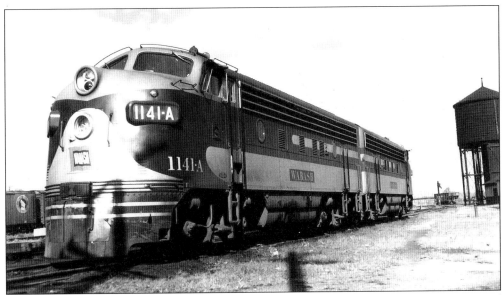

Wabash Engine No. 1141A sits at the Maumee Yard with the Water Tank in the background around 1952. (B. Lorenz.)

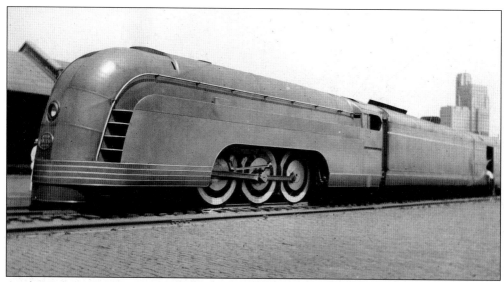

At the Toledo Middlegrounds, also known as "Piling Yard" by NYC employees, a New York Central locomotive is on display, *c*. 1938. This was one of the newly streamlined locomotives from New York Central's passenger trains. (F. D. Cairns.)

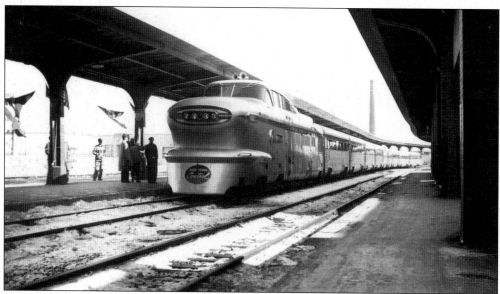

The New York Central Aero Train stopped at Toledo's Union Station *c*. 1956. (K. Hise.)

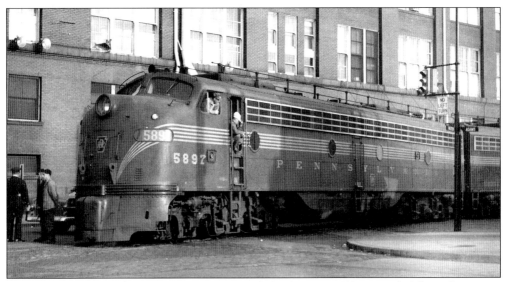

Pennsylvania Railroad Engines Nos. 5897 and 5835 rest at Water and Adams Streets in downtown Toledo, *c.* 1955. This was the locomotive used on the Toledo Railfan's excursion to Sandusky via the Pennsylvania Railroad in October 1955. (B. Lorenz.)

This is the Toledo, St. Louis & Western at Michigan Central's Junction along the Miami & Erie Canal in South Toledo in 1890. The train was called the Commercial Traveler on the Toledo, St. Louis & Western or Clover Leaf Railroad. (K. Hise collection.)

NYC Engines Nos. 5440 and 5287 run beside a passenger train out of Toledo. (Pulhuj collection.)

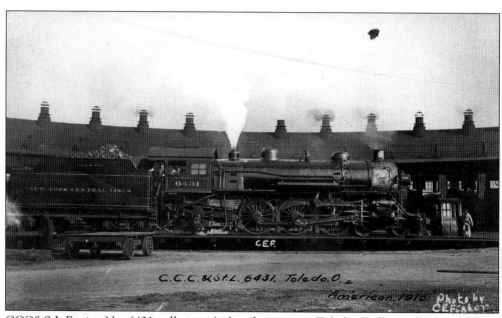

CCC&StL Engine No. 6431 pulls into Airline Junction in Toledo. (Pulhuj collection.)

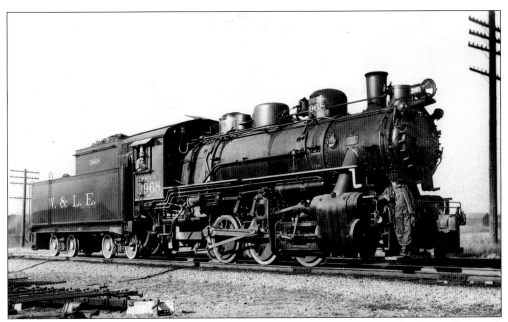

Wheeling & Lake Erie Locomotive No. 3968 travels into Toledo *c.* 1937. (Pulhuj collection.)

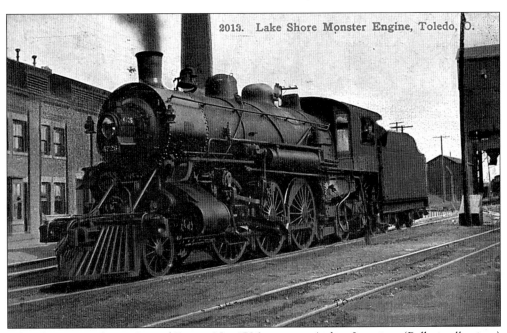

2013. Lake Shore Monster Engine, Toledo, O.

Lake Shore & Michigan Central Engine No. 4726 arrives at Airline Junction. (Pulhuj collection.)

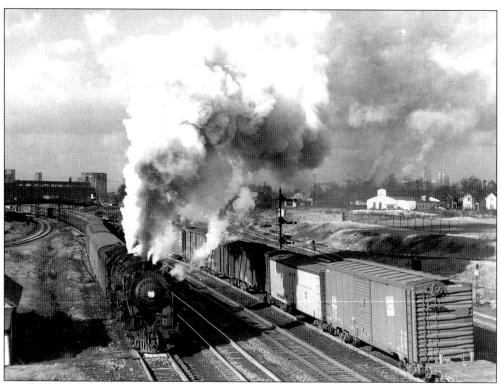

NYC Engine No. 5387 pulls the Big Four passenger train at Fassett Street around 1950, heading south off of NYC at Oakdale (B. Lorenz.)

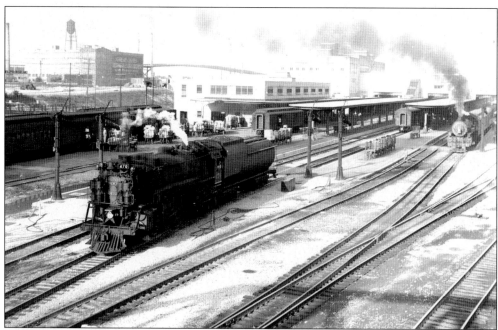

Chesapeake & Ohio Steam Locomotive No. 470 heads south from Toledo's Central Union Station, c. 1948. (B. Lorenz.)

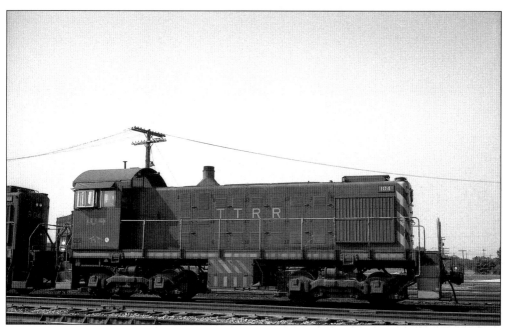

Toledo Terminal Engine No. 104 is seen here at Boulevard Yard about 1973. (Pulhuj collection.)

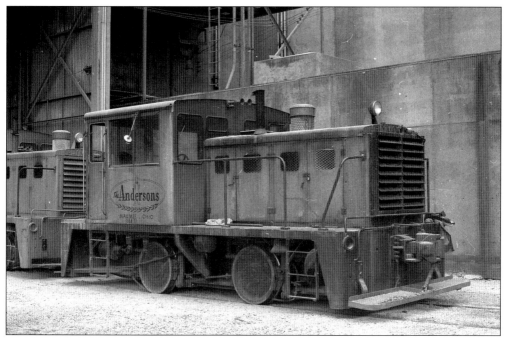

Anderson's Grain Corporation Plymouth locomotive rests here in Maumee, *c.* 1972. (Pulhuj collection.)

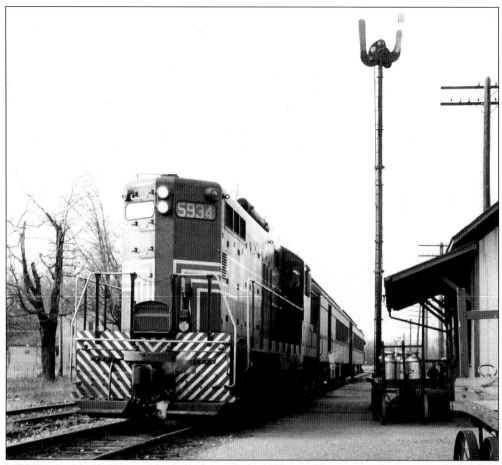

NYC Engine No. 5934 arrives at Sylvania with the Old Road passenger train in 1952. (B. Lorenz.)

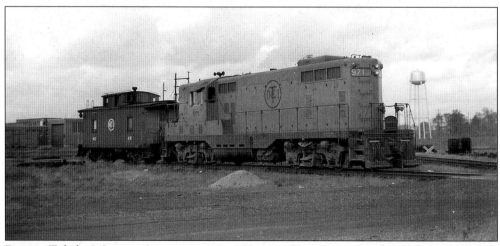

Detroit, Toledo & Ironton Locomotive No. 971 sits at Temperance Yard in Toledo along with Caboose No. 65. (K. Hise.)

Ten

PEOPLE OF THE
RAILROAD

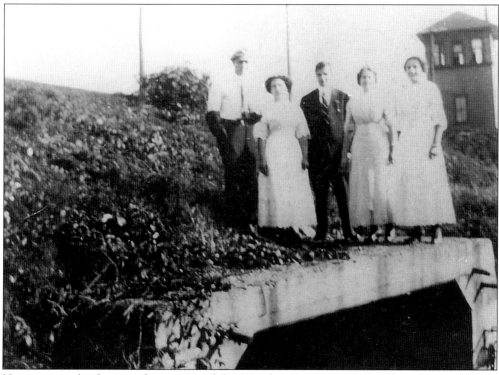

Here is an early photograph, c. 1901, of the Wooden Tower at Alexis. The concrete form in the foreground is the tunnel of the Detroit, Monroe & Toledo Shortline trolley, under construction c. 1900. The trolley ran on the west side of Stickney Avenue out of Toledo. In the Alexis area, the line went under all of the rail lines then came up to ground level for the Novi Yard to cross Benore Road at grade.

In the late 1950s, when author Hise was working as a switchman at the C&O Ottawa Yards at Erie, Michigan, they ran puller jobs that came down to Alexis to cross the NYC. They had to stop at State Line Road and call Alexis Tower for permission to cross. One old operator at that time (1956) was Roy Benedict, from Palmyria, Michigan. On ringing him up on the message phone line and asking about the block signal to go, he would often answer, "Watch the light."

Roy lived with his wife in a small, old house-trailer on the east side of the PM tracks by Alexis Tower. On weekends, they would go home to Michigan. One time, Roy gave Hise a six-inch piece of Erie & Kalamazoo strap iron rail found on his family's farm. Alexis Tower and Roy are both gone now.

This photograph of the Chesapeake & Ohio Lunch Room at Walbridge Yard was taken *c.* 1937. (K. Hise collection.)

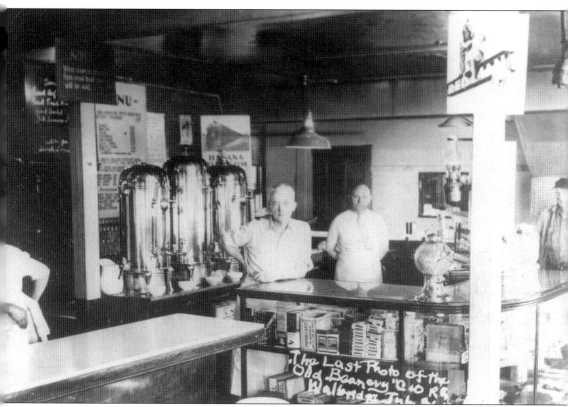

This is the last photograph taken of the Old Beanery at Walbridge Yard, c. 1937. (K. Hise collection.)

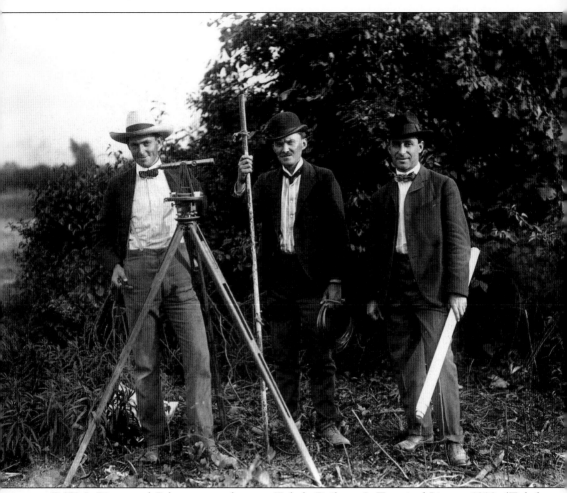

D.W. LaPierse and Selter survey the new Toledo Railway & Terminal Line *c.* 1902. (Toledo Public Library.)

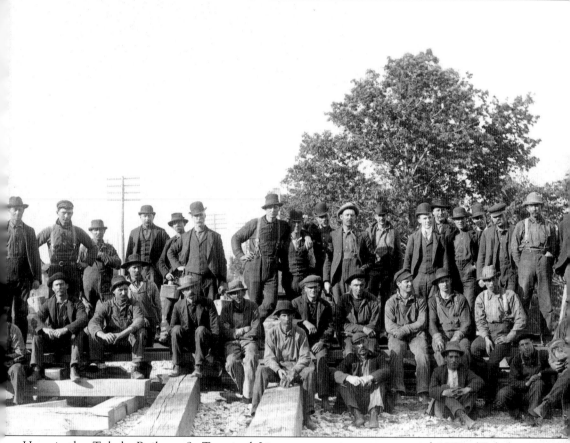

Here is the Toledo Railway & Terminal Line construction crew around 1902. (Toledo Public Library.)

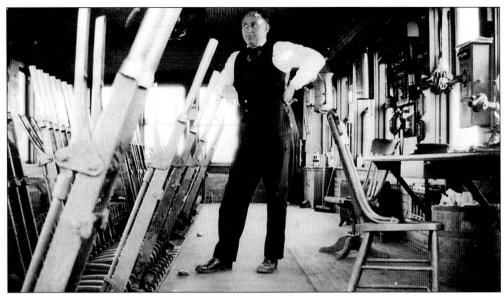

Albert G. Eberline was an operator at Alexis Tower. This c. 1926 photograph was given to author Hise from Joe Huffman, a retired PM / C&O Engineer. (K. Hise collection.)

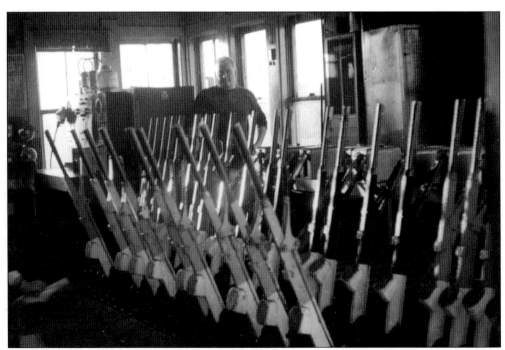

This is an interior view of the Swan Creek Tower with the Armstrong Plant levers. The levers were all manually operated and could control rods up to 1000-feet long and operate switches and signals. (K. Hise.)